SEEING SALVATION

SEEING SALVATION

IMAGES OF CHRIST IN ART

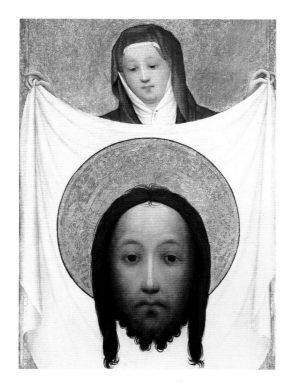

NEIL MACGREGOR
with ERIKA LANGMUIR

BBC

Title page: MASTER OF ST VERONICA *St Veronica with the Sudarium*, *c.*1420

This book is published to accompany the television series
Seeing Salvation, first broadcast on BBC2 in 2000
Executive producer: Keith Alexander · Series producer: Patricia Wheatley
Producers: Tim Robinson and Patricia Wheatley

Published by BBC Worldwide Limited,
Woodlands, 80 Wood Lane, London W12 0TT

First published in 2000
Copyright © Neil MacGregor 2000
The moral right of the author has been asserted

ISBN 0 563 55111 9

Commissioning editor: Sheila Ableman
Project editor: Martha Caute · Copy editor: Ruth Thackeray
Designer: Linda Blakemore · Picture researcher: Deirdre O'Day

Set in Sabon by BBC Worldwide
Printed and bound in Great Britain by Butler & Tanner Limited, Frome & London
Colour separations by Radstock Reproductions Limited, Midsomer Norton
Jacket printed by Lawrence Allen Limited, Weston-super-Mare

CONTENTS

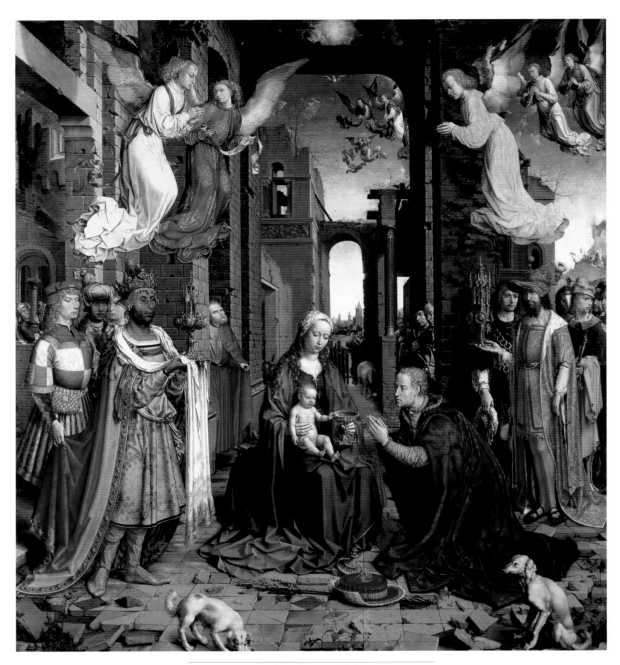

1 JAN GOSSAERT *The Adoration of the Kings, c.* 1510

INTRODUCTION

Lord, now lettest thou thy servant depart in peace, according to thy word: For mine eyes have seen thy salvation.
LUKE 2:29–30

With these words this book begins and ends. They were spoken by the old priest Simeon as he took the infant Jesus in his arms and saw in him the Saviour. In this child, Christians believe, the boundaries of the human and the divine were permanently redrawn for us all. The implications of Simeon's vision for European art are the subject of this book.

When you walk through any of the world's great collections of European painting, you cannot fail to notice how many of the pictures – and how many of the greatest – deal with the life and death of Jesus Christ. It is a subject which was for centuries the staple of Western European artists, who tried to express through painting and sculpture what Jesus's life on earth meant to them, and to everybody, for, with the exception of a small Jewish community, everybody in Europe would have agreed that the fact and the meaning of Christ's life and death were the most important notions that could be addressed.

Presumably these pictures and sculptures are still likely to be of interest to believing Christians whose faith they were made to strengthen. But most of the National Gallery's visitors today, like most of the population of Europe and America, are not believing Christians, and these pictures may well appear remote or daunting. I believe, however, that they can still speak powerfully to believers and non-believers, that they are as important to us now as a way of understanding our lives as they were when they were made. And that is because the greatest artists, in representing the life of Christ, did something even more difficult: they explored the fundamental experiences of every human life. Pictures about Jesus's childhood, teachings, sufferings and death are – regardless of our beliefs – in a very real sense pictures about us.

Because every life was held to be in some measure divine, the language of Christian art still allows Leonardo and Rembrandt, Michelangelo and Rubens, to speak to us of love and suffering, loss and hope.

Neil MacGregor

PART ONE

THE BIRTH OF A GOD

And when they were come into the house,
they saw the young child with Mary his mother,
and fell down, and worshipped him.

MATTHEW 2:11

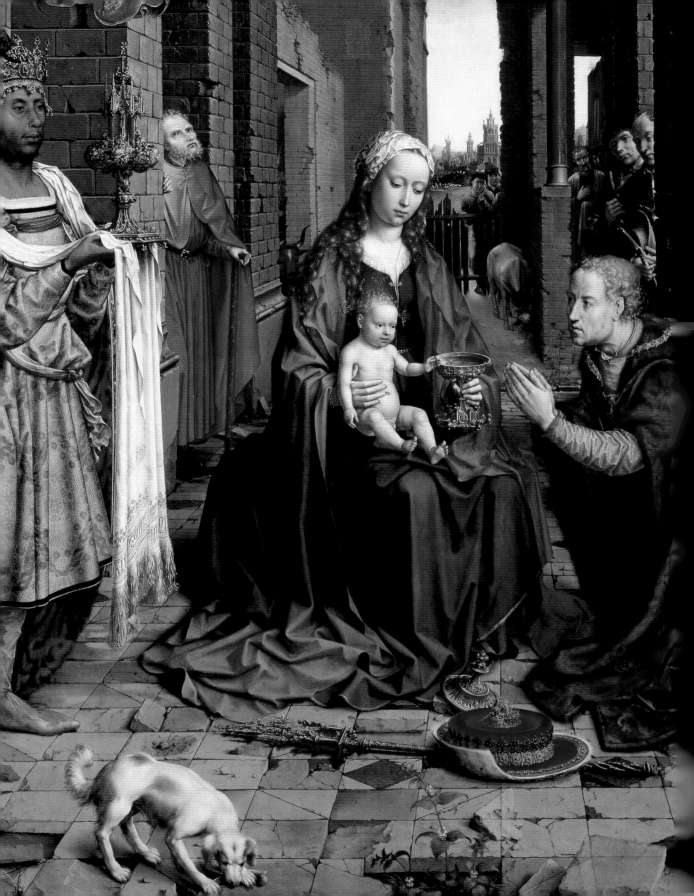

JAN GOSSAERT
The Adoration of the Kings

Towards the end of December in Palestine, a Jewish carpenter and his pregnant wife travelled from Nazareth to Bethlehem to be taxed by the bureaucrats of imperial Rome. There was no room for them at the inn, so they lodged in a stable, where the young woman, weary after the long journey, gave birth to a son. Ox and ass stood beside the manger in which the new-born baby lay, warming him with their breath. Alerted by angels, shepherds hurried down from the hills to see the baby. Three kings, guided by a star, came from the East to offer him gifts.

This, in broad outline, is the Christmas story as every schoolchild has been told it. And in this sense we are all schoolchildren. Christians and non-Christians alike brought up in the European tradition are familiar with these events, more or less heavily embroidered with picturesque detail, from Christmas cards and paintings, Christmas carols and Nativity plays, even shop window displays. In many European countries, they are re-enacted in cribs and collections of carved figures assembled at home, in churches and, especially in Italy and Germany, city streets.

We have been here so often that when we first look at Jan Gossaert's *Adoration of the Kings* [PLATES 1 and 2], which now hangs in the National Gallery in London, we instantly feel at ease. We know what we are going to find, and we know this is how it was.

Yet a second look is enough to convince us that Gossaert, who lived in the Low Countries fifteen hundred years after the birth of Christ, is not recording the story as every schoolchild knows it and even less the event as it might really have happened, even if interpreted in 'modern dress'. Wherever we turn within the painting, we find improbabilities and impossibilities, none of which, on closer examination, appears to be accidental.

The imposing ruins are a very strange stable and offer no shelter. The ox and ass peering out from among them are unlikely ever to have been installed there. No carpenter's wife was ever so lavishly turned out, in a blue dress and mantle painted with ground lapis lazuli, a pigment costlier than gold and brought to Europe with great difficulty and at great expense from Afghanistan. No mother is

likely to hold her twelve-day-old baby naked on her lap outdoors in the dead
of winter. Baby and mother appear singularly poised in the centre of the compo-
sition, graciously receiving the homage of a fantastical crowd who have obviously
changed – somewhere in the wings, as it were – out of their travelling clothes into
elaborate court and pageantry costumes.

The mother's elderly husband – his age and decrepitude emphasized by the
cane on which he leans – looks on from behind a pillar.

The Three Kings have names cleverly inscribed about their clothing like the
most elegant designer labels, or marked on the gifts they bring. Kneeling, hands
folded in prayer before the child, is Gaspar. Balthazar, the black king, stands
to the left, and Melchior to the right. Their gifts, or rather the gifts' golden
containers, could not possibly have been made at the time of Christ's birth either
in Palestine or in the East from which the wise men came. Instead, they resemble
objects used in the church worship of the artist's day. Gaspar's goblet, which he
has handed to the baby's mother and whose lid is on the floor beside his hat and
sceptre, is more properly a ciborium, in which the Host, the consecrated wafer
used in the Eucharist, is kept. Here it holds gold coins, one of which the preco-
cious infant seems to be handing back to the king with a smile. It is not clear
which of the other two kings brings frankincense, and which myrrh.

The angels come as no surprise, for they are part of the story, but descending
on golden rays from the miraculous guiding star is a dove, planing on outstretched
wings above the mother and child.

And as we look further into the picture, we see that it shows events that
happened at different times. The shepherds, who came the night the child was
born, are still here, on Twelfth Night, when the wise men came, watching them
from behind the picket fence. And, if you look really closely, you can spot the
angel announcing the happy event in the fields in the far background, before they
even set off for Bethlehem and the stable.

We could go on pointing out details invisible in reproduction. The capital of
a column to the right of the mother and child is sculpted with the Old Testament
scene of Abraham about to sacrifice his son Isaac to God, until stopped by an
angel. On the top of Gaspar's highly worked sceptre the goldsmith has sculpted a
figure of Moses with the stone tablets of the Law, given him, as Exodus tells us,
by God on Mount Sinai.

What is going on? How did a painting as seemingly obvious in subject as
Gossaert's turn out to be so packed with obscure complexities?

Christianity is, like Judaism and Islam, a religion of the book. Along with
them it proposes a set of teachings and practices deriving ultimately from texts

(in some cases, the same texts), which have been meticulously expounded by the learned, and enlarged and enriched by centuries of tradition. In all three faiths mankind strives for God through the Word. But unlike Muslims and Jews, Christians (or at least the early Christians) have *seen* their God; for Christianity is the religion of the Word made flesh, and, largely as a consequence, it is also a religion of the image.

Making an image of God who has become man is, as we shall see, a tricky business. Artists attempting it have to negotiate a series of specifically visual problems, unknown to authors. Paradox is easy to write, but hard to paint. The Gospel tells us quite straightforwardly that the helpless, swaddled infant is in reality God incarnate, but how do you *show* that it is God in nappies, that the purpose of this child is to redeem the world by his death? How can a painter make clear that the man brutally being put to death on a cross, to every human eye a man completely ordinary and like any other, is also totally divine; that limitless power has chosen absolute submission?

Like all great religious images, Gossaert's *Adoration* neither simply illustrates a religious story nor interprets it according to the painter's own caprice. It translates into a visual language a pictorial theology, a distillation of the Western Church's teachings on the dual nature of Christ, as at once God and man, taking into account centuries of pious poring over sacred texts to find hidden meanings and correspondences, and to wring from them every drop of possible meaning. Gossaert's picture does not show us the birth of Christ: it paints a meditation on the meaning of the birth of Christ and why it matters to us now.

Like all works of art, it reflects the interests of those who paid for it, and those who viewed and used it, as much as the concerns of the artist who made it. We can perhaps quickly resume the latter. Gossaert clearly wished to demonstrate his dazzling mastery of the exacting techniques of oil painting developed in the Low Countries through the fifteenth century, his familiarity with the last word in the crafts of others: fashionable goldsmiths, weavers, embroiderers, cobblers and all, and to be recognized as a learned artist who consorted with scholars, princes and prelates. As a token of his own Christian belief, his personal witness to the birth of his Saviour, he may have introduced his self-portrait in a small, barely visible figure standing in the doorway behind the ox.

Gossaert's *Adoration*, made around 1510, was an altarpiece, probably painted for the Lady Chapel in the church of a Benedictine abbey in Geraardsbergen in East Flanders. Its main function was to serve as the focus of worship at the altar, the celebration of the eucharistic service, in this case the Roman Catholic Mass, which re-enacts the Lord's Supper – when Christ gave

bread to his disciples, saying, 'Take ye, and eat. This is my body' – and his sacrifice on the Cross, through which his body becomes the bread of life.

This function, as part of the eucharistic worship, may well explain why one of the gold pieces brought by Gaspar in the ciborium is given back to him by the Christ Child. The gesture is that of a priest administering Holy Communion as he takes from the ciborium a wafer to give to the communicant. Gold was, *par excellence*, the tribute paid by kings to a king, after the example of Solomon. The carpenter's wife's son is, in fact, a King among Kings – but this royal tribute will be redeemed with his own body, here shining in its nakedness. Christ the King, in his infinite charity, is also Christ the Saviour, the Child born to die in atonement for our sins.

According to St Paul and biblical commentators through the centuries, the redemptive sacrifice of Christ, the son of God, recorded in the Gospels, was fore-shadowed by Abraham's willingness to sacrifice his son Isaac in the Old Testament – the scene sculpted on the capital of one of the columns. The birth of Christ was recorded as the culmination of the Old Testament, the moment at which the old Jewish law was fulfilled and replaced by the new dispensation. And so we see in the ruins the fading away of Judaism, the replacing of the Synagogue and the Temple with the Church. The Law of the Hebrew Bible has been super-seded by Christ's Grace of the New Testament, whose Church, for Roman Catholics embodied in his mother Mary, rises out of these ancient bricks and stones. For those who can come close enough to the picture to see it, and who know the Gospels by heart, Gaspar's sceptre laid before the Child reinforces the message. On it the tiny figure of Moses holds the Ten Commandments, God's instructions to the Jews which are now to be completed: 'For the law was given by Moses, but grace and truth came by Jesus Christ' (John 1:17).

Jesus Christ is the son of the carpenter's wife, but he is not her humble husband's child. He is, for Christians, one of the persons of the Holy Trinity of God the Father, the Son and the Holy Spirit. The dove here, and in innumerable other Christian images, is the visible embodiment of the Holy Spirit. John the Baptist, having baptized Jesus Christ, says (in the words of St John's Gospel): 'I saw the Spirit descending from heaven like a dove, and it abode upon him' (John 1:32). In this picture then, while Isaac and Moses point backwards, the dove looks forwards to the Baptism of Christ and the public declaration that he is God's son.

The dove seldom appears in images of the Adoration, but 6 January, the day on which the Western Church now celebrates the Epiphany, the coming of the Kings on the twelfth night after the birth of Christ, has since the early centuries of the Church been the feast day of his Baptism. The word Epiphany, or

'apparition of God', now used to mean Christ's revelation to the Gentiles in the persons of the Kings, who are held to represent all non-Jewish peoples, was a word first applied to the Baptism. Also celebrated on 6 January, if a little less fervently, was Christ's first miracle, when his divine nature became apparent to many of his followers, as he turned water into wine at the wedding in Cana. Gossaert is showing us different ways and moments in which Jesus was revealed as God.

The precise day of Christ's birth, which remained in doubt for centuries, was also for long dated by many to 6 January (which might account logically for the presence here of the shepherds). It was the Christians in Rome who first, some time in the fourth century, assigned it to 25 December, the winter solstice and the birthday of a pagan sun god, Mithras – on the grounds that Christ was the true unconquered Sun. But even when the date was generally agreed in the West, Christmas, Christ's 'birth in the flesh', seemed, as we shall see, of no great importance until very much later. For as St John Chrysostom, a fourth-century Christian cleric, wrote: 'It was not when he was born that he became manifest to all, but when he was baptized.' Significantly, and we will also return to this, the same author believed that 6 January would also be the date of Christ's Second Coming at the end of the world.

Precisely how much of this obscure early church history Gossaert knew may be debatable, but that he knew a considerable amount about the later theology is clear from his inclusion of the dove. And since the dove is the visible sign of the Holy Spirit making manifest the divine nature of this Child, we may reasonably conclude that the excessively bright and haloed star from which it descends, and which parts the clouds so that it seems to reside in a heaven beyond the physical sky, represents something more than the star which the kings followed. It has been convincingly argued that it symbolizes God the Father. Gossaert's Christ Child is not only visibly divine, we are to view him as one of the persons of the Trinity.

Even now we are far from having exhausted the doctrinal subtleties of this picture – and although in this book I shall focus almost exclusively on the image of Christ, it is instructive to see how other, related themes are depicted. We can pass over rapidly the fact that there are here nine angels, representing the nine heavenly hierarchies derived from St Paul, which organized angels into categories long established and lovingly elaborated in the Middle Ages – seraphim, cherubim, thrones, dominations, virtues, powers, principalities, archangels and angels. Gossaert, perhaps luckily for his viewers, does not distinguish them by colour or number of wings. One of them simply holds a suitable scroll, inscribed *Gloria: in: excelsis: deo:*, Glory to God in the Highest.

More significant is Gossaert's treatment of the Virgin Mary. If the altarpiece's original location was, as the earliest documents suggest, a chapel dedicated to her, part of its function would have been to honour her in her own right. And that is precisely what the painting does. Mary's precious blue clothing is traditional; the great medieval Italian poet Dante calls her 'the beautiful sapphire by which the brightest sky is ensapphired'. But she is not always as much the centre of attention as she is here. Near the hem of the white cloth held by Balthazar are embroidered the opening words of a hymn composed in her honour, the *Salve Regina*: 'Hail Queen, Mother of mercy, our life, our sweetness and our hope … most gracious advocate.' We, the spectators, are invited to pray to her to intercede with her son on our behalf when the hour of judgment comes.

The cult of Mary was assisted by a Christian reading of the Old Testament, above all by an allegorical interpretation of the *Song of Songs*, now believed to be a collection of love poems to be recited and sung at weddings. Christians identified Christ with the Lover and Bridegroom mentioned in these texts; and they understood the Beloved and Bride as a metaphor of the Virgin Mary, and of the Christian Church itself. It is mainly as an embodiment of the Church of Christ that Mary reigns over this picture. It is she who holds the ciborium offered by Gaspar. Christ sits in her lap as upon a throne – a throne which is simultaneously the altar on which his redeeming sacrifice is perpetually re-enacted in the celebration of the Mass. Mary, the Queen of Heaven, Christ's Virgin Mother and Bride, indeed the Church itself, has also become God's Throne of Mercy.

We have probably looked closely enough at Gossaert's altarpiece to see how a major European artist of the fifteenth century resolved the problems of painting both the event and the theology of the Adoration of the Christ Child as it was understood in his day. We can, I think, admire his success in depicting the ungraspably complex nature of the Christ Child: King of Kings and humbly born, fully divine and fully human, priest and sacrifice. But if we turn from tradition to textual sources, and read again the two Gospels which give an account of these events, there are surprises in store. For the angels, shepherds and stable appear only in the Gospel of Luke, who seems to be describing a quite different event from Matthew, with his wise men from the East. And the New Testament nowhere mentions an ox and an ass, nor does it describe the visitors as Kings. Only by returning to the earliest art of Christianity can we really begin to trace the long and tortuous route by which Gossaert and his contemporaries came to produce the kind of image with which we are now so familiar, and thus discover how that image was constructed from those words, and how it changed as religious ideas and beliefs changed over time and in different places.

A KING AMONG KINGS

Rather bewilderingly for the casual reader, the first verses of the New Testament are merely a long list of names. They are particularly disconcerting if the casual reader has to read them out loud, for they include names like Ezekias, Salathiel and Zorobabel, which few of us can pronounce with total confidence. But Matthew's list is there for a crucial purpose. The names are those of Joseph's ancestors, and they include not just Abraham and Isaac, but David and Solomon, the great Kings of the Jews, proof that on his foster-father's side the child Jesus was nonetheless of the house and lineage of David and belonged to a line of kings. And this royal nature is recognized in the next chapter of Matthew's Gospel, when the wise men come to worship the King of the Jews. But that kingship was, as all the Gospels made clear, not of this world – it would be realized fully on earth only at the end of time. And so from the beginning the Church linked the first humble coming of Christ as the King the Jews did not recognize with his second coming as ruler and judge of all. The Anglican collect for the first Sunday in the church year, the beginning of Advent, when spiritual preparations for Christmas get under way, makes it clear:

> *Almighty God, give us grace that we may cast away the works of darkness and put upon us the armour of light, now in the time of this mortal life, in which thy son Jesus Christ came to visit us in great humility, that in the last day when he shall come again in his glorious Majesty to judge both the quick and the dead, we may rise to the life immortal.*

This, then, was the task painters had to address: how to show in an image that this child, born in poverty, was not just King of the Jews, but the universal King who would judge us all at the last day. We have seen how Gossaert tackled it. But his solution was arrived at only slowly, over centuries of theological debate and artistic invention.

The Gospel of Mark, generally accepted as the earliest of the four Gospels and dated to between AD 65 and 75, tells us nothing at all about Christ's birth or infancy, but begins directly with an account of John the Baptist preaching in the wilderness, and the baptism of Christ with the descent of the Spirit like a dove. No help for Christmas painters here.

Matthew's Gospel, usually dated to about AD 85 or 90, is believed to have been written for a community in Antioch, Syria, made up of Christians largely of Jewish origin.

Matthew, as we have seen, begins with the genealogy of Jesus Christ, traced back – through Mary's husband, Joseph – to demonstrate that Jesus is Israel's long-awaited Messiah, come to bring about the Kingdom of God. Later in the chapter, Jesus's conception through the Holy Spirit is confirmed by an angel sent to Joseph in a dream. The events surrounding the birth of Jesus are recounted in the second chapter:

Now when Jesus was born in Bethlehem of Judaea in the days of Herod the king, behold, there came wise men from the east to Jerusalem,

Saying, Where is he that is born King of the Jews? for we have seen his star in the east, and are come to worship him.

When Herod the king had heard these things, he was troubled, and all Jerusalem with him.

And when he had gathered all the chief priests and scribes of the people together, he demanded of them where Christ should be born.

And they said unto him, In Bethlehem of Judaea: for thus it is written by the prophet.

And thou Bethlehem, in the land of Juda, art not the least among the princes of Juda: for out of thee shall come a Governor, that shall rule my people Israel.

Then Herod, when he had privily called the wise men, enquired of them diligently what time the star appeared.

And he sent them to Bethlehem, and said, Go and search diligently for the young child: and when ye have found him, bring me word again that I may come and worship him also.

When they had heard the king, they departed: and, lo, the star, which they saw in the east, went before them, till it came and stood over where the young child was.

When they saw the star, they rejoiced with exceeding great joy.

And when they were come into the house, they saw the young child

*with Mary his mother, and fell down, and worshipped him: and when
they had opened their treasures, they presented unto him gifts: gold, and
frankincense, and myrrh.*

*And being warned of God in a dream that they should not return to
Herod, they departed into their own country another way.*

*And when they were departed, behold, the angel of the Lord
appeareth to Joseph in a dream, saying, Arise, and take the young child
and his mother and flee into Egypt, and be thou there until I bring thee
word: for Herod will seek the young child to destroy him.*
MATTHEW 2:1–13

So Matthew gives us some, but only some, of our familiar picture; for he tells us
nothing of the circumstances of the birth itself.

The Gospel traditionally attributed to 'the beloved physician' Luke, a com-
panion of St Paul's, is thought to have been written late in the first century for a
predominantly Gentile, Greek-speaking Christian community.

After a short prologue, Luke devotes his first two chapters to an account of
the birth and childhood of both John the Baptist and of Jesus, whose mothers,
Elizabeth and Mary, are said to have been cousins. The Christmas story proper
begins in Chapter 2. Luke, alone among the Gospel writers, gives us details of the
birth, but there is no trace here of the wise men: the only Adoration he mentions
is that of the shepherds.

*And it came to pass in those days, that there went out a decree from
Caesar Augustus, that all the world should be taxed.*

(And this taxing was first made when Cyrenius was governor of Syria.)

And all went to be taxed, every one into his own city.

*And Joseph also went up from Galilee, but of the city of Nazareth,
into Judaea, unto the city of David, which is called Bethlehem:
(because he was of the house and lineage of David:)*

To be taxed with Mary his espoused wife, being great with child.

*And so it was, that, while they were there, the days were accom-
plished that she should be delivered.*

*And she brought forth her firstborn son, and wrapped him in
swaddling clothes, and laid him in a manger: because there was no
room for them in the inn.*

*And there were in the same country shepherds abiding in the field,
keeping watch over their flock by night.*

And, lo, the angel of the Lord came upon them, and the glory of the Lord shone round about them: and they were sore afraid.

And the angel said unto them, Fear not: for, behold, I bring you good tidings of great joy, which shall be to all people.

For unto you is born this day in the city of David a Saviour, which is Christ the Lord.

And this shall be a sign unto you: Ye shall find the babe wrapped in swaddling clothes, lying in a manger.

And suddenly there was with the angel a multitude of the heavenly host praising God, and saying,

Glory to God in the highest, and on earth peace, good will toward men.

And it came to pass, as the angels were gone away from them into heaven, the shepherds said one to another, Let us now go even unto Bethlehem, and see this thing which is come to pass, which the Lord has made known unto us.

And they came with haste, and found Mary, and Joseph, and the babe lying in a manger.

And when they had seen it, they made known abroad the saying which was told them concerning this child.

And all they that heard it wondered at those things which were told them by the shepherds.

But Mary kept all these things, and pondered them in her heart.

And the shepherds returned, glorifying and praising God for all the things they had heard and seen, as it was told unto them.

And when eight days were accomplished for the circumcising of the child, his name was called JESUS, which was so named of the angel before he was conceived in the womb.

And when the days of her purification according to the law of Moses were accomplished, they brought him to Jerusalem, to present him to the Lord.

LUKE 2:1-22

Finally, St John's Gospel. Written late in the first century, perhaps after the other three, it is both the most literary in its carefully crafted form, and the most abstract and conceptual of the four. John avoids any description of Jesus's birth or infancy, writing instead of the astonishing mystery of the Word made flesh, casting the incarnation as the cosmic struggle between the light of the world and

the darkness that surrounded it. John, like Mark, begins his account of Jesus's life with the Baptism and the descent of the Holy Spirit like a dove. He then goes on immediately to the calling of the disciples and the first showing of Christ's divine power in the miracle at the marriage in Cana.

The story of the distinguished visitors who bring gifts of gold, frankincense and myrrh to the new-born Christ Child thus appears only in Matthew, and that of the shepherds only in Luke. Nowhere does Matthew mention the visitors' names, nor that they were three in number, nor that they were kings. And neither Luke nor Matthew specifies the ox and the ass now so indispensable in any representation of the Nativity or the two Adorations.

Let us first dispatch, as it were, these sympathetic animals. Their presence at the manger is not as obvious, nor as benign, as art has made us believe. It originates in a verse from the Book of Isaiah (1:3): 'The ox knoweth his owner, and the ass his master's crib: but Israel does not know, my people does not consider.' Now biblical scholars and commentators argued that every verse of the Bible can illuminate every other verse, if read aright. And so the passage came to be associated with Luke's account of the new-born Jesus being laid in a manger and Isaiah's lament was interpreted by Christians as a prophecy of the Jews' failure to recognize Jesus Christ as the Messiah. The ox and ass are in the stable because that would not be surprising. And they are there to contrast the Jews, who do not see their saviour, with the non-Jewish wise men who have travelled to pay him homage. It is not a pleasant message.

Isaiah was the Old Testament prophet who played perhaps the greatest part in Christian theology. The Book of Isaiah has even been called the 'Fifth Gospel', because it recounts the life of the Messiah in such a way, wrote the great translator of the Bible into Latin, St Jerome, as to make one think he is 'telling the story of what has already happened rather than what is still to come'. It is more often quoted in the New Testament than any other book of the Hebrew Bible except the Psalms. Some commentators believe that Matthew's own version of the events surrounding Christ's birth may be indebted to Isaiah:

Arise, shine: for thy light is come, and the glory of the Lord is risen upon thee … And the Gentiles shall come to thy light, and kings to the brightness of thy rising. The multitude of camels shall cover thee, the dromedaries of Midian and Ephah; all they from Sheba shall come: they shall bring gold and incense; and they shall shew forth praises of the Lord.
ISAIAH 60:1, 3, 6

More probably, however, these particular verses influenced the story and inter-
pretation of the Adoration only much later, for Matthew, as we have seen, identi-
fies the gift-bearing visitors not as kings but only as wise men. It was subsequent
biblical scholars, who, reading Isaiah and Matthew together, as with the ox and
the ass, brought the kings into the stable. Nor does Matthew mention camels and
dromedaries, inconspicuously present in the right-hand background of Gossaert's
Adoration, although – as that ever-obliging every-schoolchild knows – more
prominent in many other paintings of the subject.

When Christians began to picture Matthew's visitors to the manger, they
pictured them in his words as wise men from the East – Magi. (A Magus was a
priest of the Medes and Persians.) These early Christian artists were, of course,
living and worshipping in a context quite different from Gossaert's. And so the
significance of the Magi, and their appearance, were very different from what we
have come to expect.

But none even of these images is contemporary with St Matthew's Gospel.
A specifically Christian art did not apparently emerge until over a hundred years
after the Gospel texts were written, over two hundred years after the birth of
Jesus Christ, and in centres – notably Rome – far away from the places in
Palestine where he was born, lived, gathered together his disciples, preached to his
followers and was killed.

The reason for the long absence of imagery is obvious: Jesus and those
who first believed in him were Jews; he proclaimed in himself the fulfilment of
ancient Jewish prophecy, enshrined in the sacred texts of Judaism. These same
texts prohibit the making of images. In the second commandment to Moses God
instructs Israel:

> *Thou shalt not make unto thee any graven image, or any likeness of any*
> *thing that is in heaven above, or that is in the earth beneath, or that is*
> *in the water under the earth: Thou shalt not bow down thyself to them,*
> *nor serve them, for I the Lord thy God am a jealous God.*
> EXODUS 20:4–5

From earliest times Jews had lived surrounded by peoples who believed in
multiple gods and worshipped their images – which, we must imagine, is why the
commandment was issued in the first place. Since making images seems to be such
a universal human drive, it is remarkable that Jews observed the second com-
mandment to the letter as long as they did, and perhaps not surprising that the
Old Testament tells of periodic backsliding into the worship of idols.

But in Rome, where religious images of all sorts were venerated, and in other cities throughout the Roman empire, hostility towards imagery was diluted, even among the Jews. By the third century, Christians as well as some Jewish groups had come to interpret the second commandment as an interdiction of idolatry rather than a ban on all representational art. They understood by this that God – who in the Bible is heard but whose face is never seen – must not be pictured. In the early centuries, Christians did not generally extend the prohibition of images of God to the depiction of Jesus Christ, God made man. Later, when Islam, founded in the seventh century, again invoked the letter of the second commandment (thus going on to develop an artistic tradition based almost entirely on calligraphy and geometric forms), the question of representing Christ would be reopened – with, as we shall see, profound consequences for Christian art. At the Reformation in Western Europe, the question again became one of burning importance and, as most Protestants will know, it has never quite gone away since.

For the early Christians, cult images – idols – meant monumental statues. During many centuries in the West, and still today in the Eastern Church, only two-dimensional images, or small-scale objects in gold or ivory, or low-relief carvings on stone, were acceptable in places of worship.

But the problem of how to decorate churches did not really affect the beginnings of Christian art. The early Christians celebrated the Eucharist very simply by breaking bread together, praying and preaching, in each others' houses. Christian art, now so intimately associated with Christian worship, did not originate in churches, because the early Christians had none. What they did have was places where they buried their dead.

Unlike most of the pagans, Jews and Christians did not cremate their dead. Since Roman law forbade any burials within the city, the dead were inhumed in specially designated areas outside the city walls. As pressure of numbers grew, these were extended underground, producing the catacombs: series of long passages lined with tombs stacked one above the other along the walls, once enclosed with marble slabs, now usually open and lying empty. The pagans called such a place a necropolis, a city of the dead. To the Christians, it was a cemetery, from the Greek word for dormitory, a place to sleep in. The faithful assembled there had not been obliterated but lay in the sleep of death, awaiting the resurrection in the flesh, when they would wake to join Christ, body and soul, in Paradise.

The galleries are interrupted, here and there, by small chambers in which whole families, or groups of associates, were entombed so as to remain near each other. And here, in these chambers the living could also gather: not in the first place to hide from persecution, but for prayer, for commemorative meals in the

company of the sleeping dead, all awaiting together the fulfilment of the promise of life everlasting.

The catacombs were, therefore, places of hope and looking forward. Hopeful inscriptions and symbols were carved on the marble slabs, and the chambers were painted with images of resurrection and God's triumphant intervention to save us from perpetual destruction. Any visitor today can see that this decoration was never a high-quality job. It is cheap and cheerful, made by jobbing painters more used to working in modest homes than princely palaces – suitable for the modest, if prosperous, community of believers who met here.

In one such chamber, the Capella Greca (or Greek Chapel) in the Catacomb of Priscilla on the Via Salaria in Rome, we find the common, everyday vocabulary of Roman domestic art, deftly adapted to the Christian message, cheek by jowl with an astonishing medley of scenes of salvation drawn from both New and Old Testaments and the Apocrypha, as well as classical myth. There are garlands and festoons of flowers and fruit. Moses strikes water from the rock. Shadrach, Meshach and Abednego are saved from the burning fiery furnace as the prophet Daniel describes; Susanna, in the apocryphal book that bears her name, is ogled by the wicked elders, falsely accused, and her reputation vindicated. Jesus heals the paralytic, and raises Lazarus from the dead. The mythical phoenix rises from her ashes. And nature is reborn in the cycle of the seasons.

And it is here, among this company, in what is probably the oldest surviving image of the Adoration, that we find the Magi [PLATE 3]. They are clearly nothing to do with Christmas and its celebrations as we now understand them; the figures are surrounded by no stable, no manger, no animals. Like those saved from the flames and like Lazarus raised, the Magi point forward to a future salvation: they move to greet Christ at his first coming, as all believers will move to greet him at his Second Coming. No wonder St John Chrysostom dated both events to 6 January.

Like everything else here, the Magi direct our thoughts towards our resurrection at the end of time. Since all those gathered in the catacombs were certain by virtue of their faith that they would join Christ in Paradise, the idea of a Last Judgment as something to fear would probably not have presented itself urgently. But it would do so presently – and the Church still teaches us to use Advent to prepare ourselves for judgment. It is an aspect of the Adoration we may today largely have lost sight of, but it was to be of profound importance to the Church, and, necessarily, therefore to artists.

There are here three Magi. But Matthew's text gives no number, and in the early centuries sometimes two, sometimes four were pictured. It was, however, quickly – and not unreasonably – decided that as there were three gifts, there must

have been three visitors. Not many people bring two presents; no wise man, surely, would have been foolish or rude enough to come with none.

We know the figures in the Capella Greca are Magi, because they wear the Phrygian cap, a soft cloth bonnet associated in the ancient world with the countries around and beyond modern Turkey. They are dressed in green, red and white. They continue to be painted in these colours for many centuries, and although colour symbolism is a tricky subject we can perhaps hazard a guess as to what the colours might signify. Green has always been associated with springtime vegetation, the return of life after death. Red is the colour of blood and sacrifice. References to white as the colour of purity and innocence are found throughout the Bible. All these have obvious relevance to the Child of a Virgin born to restore humanity through his suffering. Other meanings, as we will see, will be added later, but they all reinforce the same message: we shall be reborn through the sacrifice of the innocent Child that the Magi – and we with them – have come to adore.

There is nothing in any way royal about this image of the Magi, or about the catacombs. But two centuries after the catacomb paintings were made, Christianity was no longer a minority religion, one sect among many. As it was transformed, so were its buildings and the images they contained.

After 313, when the Emperor Constantine had granted Christians freedom of worship, they erected purpose-built churches as meeting places and for the public celebration of the Eucharist. As a consequence, Christian art inevitably moved from a domestic to a monumental scale, a development that quickened after 324, when Christianity became a state religion and grandiose churches began to be commissioned by the emperor himself. Although remodelled and rebuilt by later generations, Constantine's magnificent Roman basilicas, among them the Lateran and the Vatican, continue to impress by their sheer scale.

But however rich in churches, Rome was losing in central political importance. Subjected to relentless waves of barbarians from Northern Europe, the city of pagan emperors and Christian martyrs fell into decline. In 330 Constantine founded a new city in Byzantium, a small town on the Straits of Bosphorus which divide Europe from Asia Minor. The new city was named Constantinople, after the emperor, and dedicated to the new Christian religion. Captured by the Turks in 1453, it is now known as Istanbul.

Constantinople became the Roman emperors' residence in the Eastern parts of their domain. The capital of the Western, or Latin, half was moved from Rome first to Milan and then, shortly after 400, to Ravenna, an important port on the Adriatic coast, with easy access by sea to Constantinople.

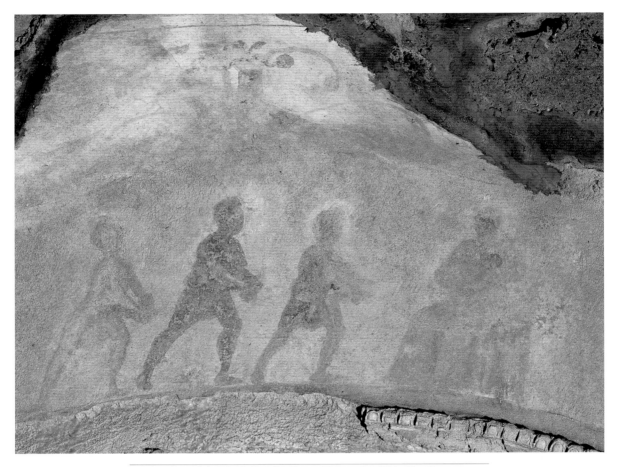

3 *Adoration of the Magi*, Capella Greca, Catacomb of Priscilla, Rome, *c.* 200

4 (OPPOSITE) Apse mosaics, view of the whole, San Vitale, Ravenna, completed *c.* 547

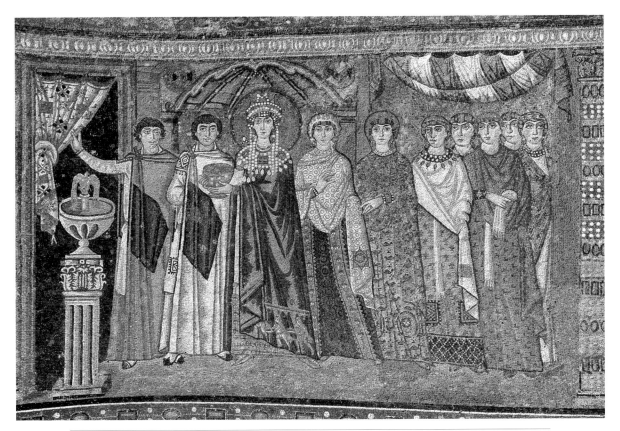

5 *Empress Theodora and her Attendants*, detail of apse mosaics, San Vitale, Ravenna, completed *c.* 547

6 (OPPOSITE) Detail of above showing the *Adoration of the Magi* on the hem of Theodora's dress

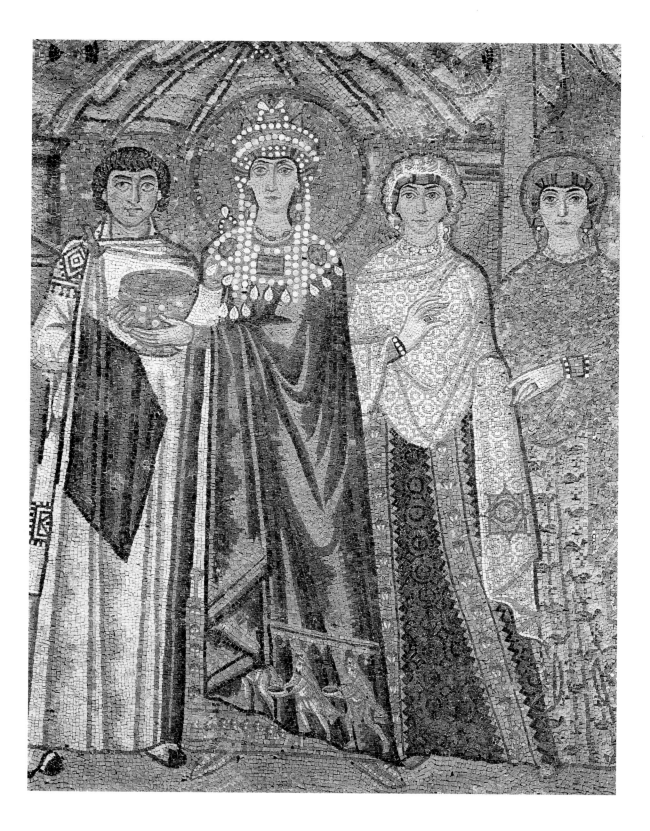

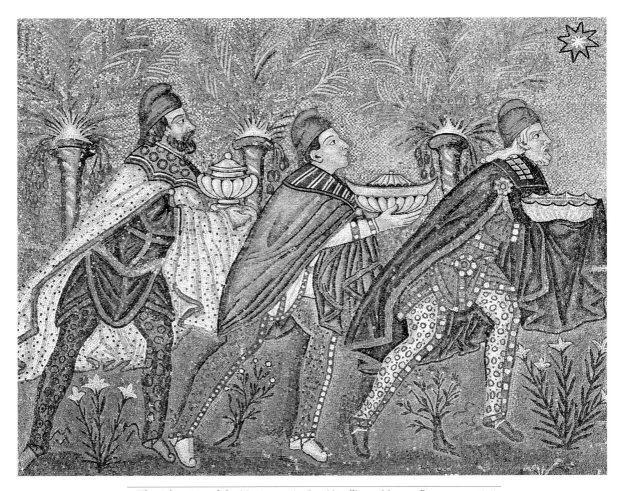

7 *The Adoration of the Magi*, mosaic, Sant'Apollinare Nuovo, Ravenna, 556–69

8 (OPPOSITE) *Madonna and Child*, mosaic, Sant'Apollinare Nuovo, Ravenna, 556–69

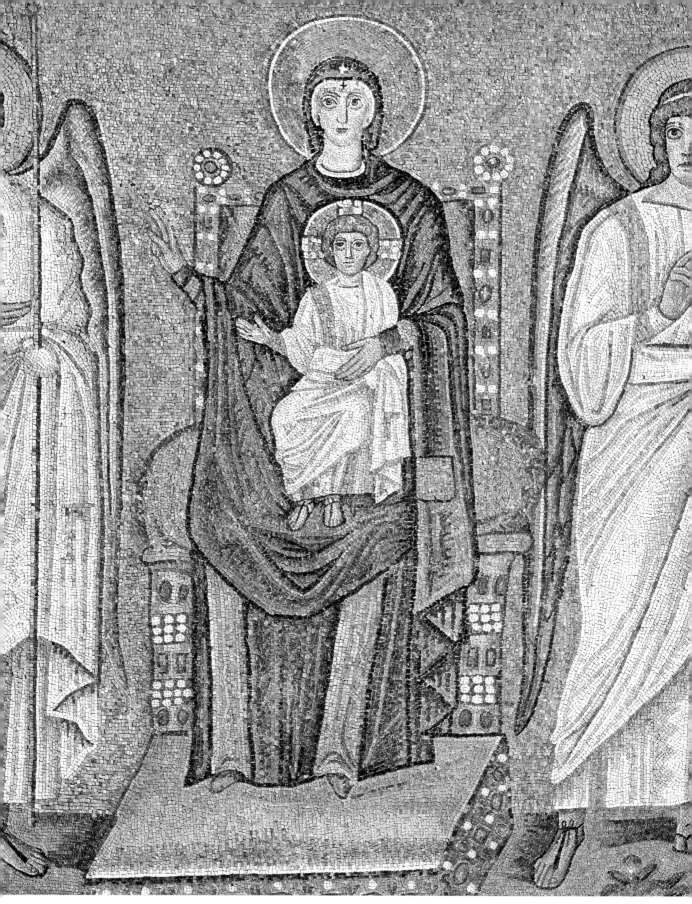

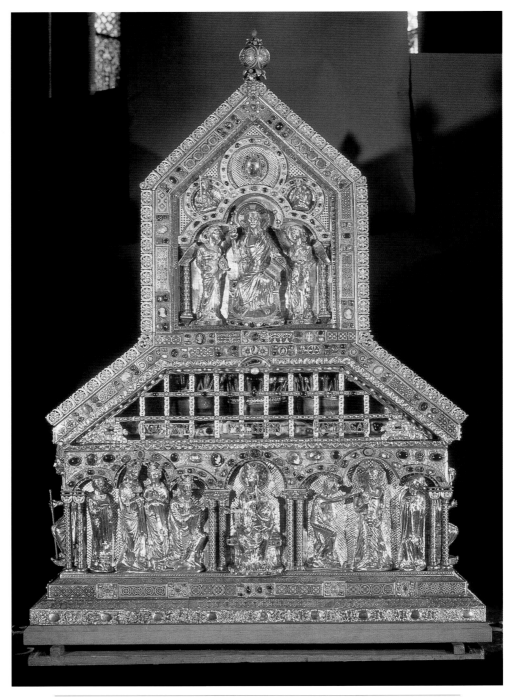

9 NICOLAS OF VERDUN *Adoration of the Kings, with Otto IV and the Baptism of Christ,*
Reliquary of the Three Kings, Cathedral, Cologne, begun 1181

10 (OPPOSITE) Interior of the Chapel of the Magi, Palazzo Medici-Riccardi, Florence, 1459–61

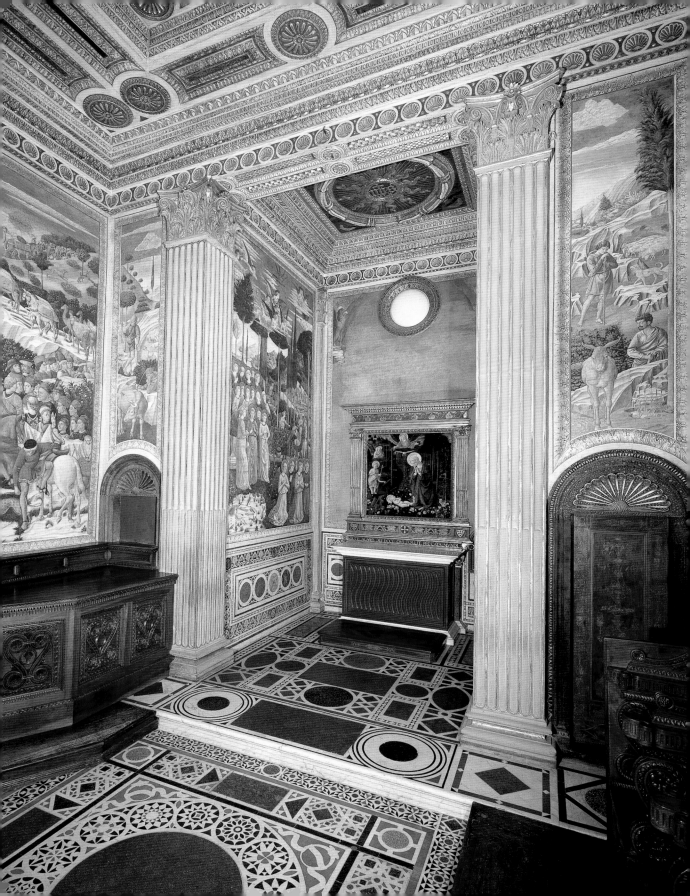

From the elaborately carved and gilded ceiling, through the choir stalls of walnut wood, to the floor inlaid with precious marbles and porphyry in imitation of imperial Christian churches – but incorporating Medici family emblems – everything is luxurious and expensive. The murals, with their abundance of detail, meticulous execution and costly pigments, give the effect of hugely expanded pages from illuminated manuscripts. The chapel was conceived as a single, highly wrought work of art. It is no less coherent a statement of the theology of the Magi as we have seen it developing over the centuries, but presented now with a very particular spin – needless to say, in honour of the Medici.

The chapel has been considerably altered. Most obviously, the west wall has been brought forward in part – brutally cutting in half the white mule of the oldest of the Three Kings – to accommodate a new staircase, to which the chapel's entrance has been moved.

Until these changes were made, you entered the chapel through a different door (now in the private apartments of the Prefect of Florence), passing beneath a painting of the sacrificial Lamb, on an altar, surrounded by the seven candelabra and seven seals of Revelation. Immediately in front is the altar of the chapel itself, with its altarpiece of a mystic Nativity by Filippo Lippi. The original is now in Berlin, but the copy still shows clearly the link the artist intended between the Lamb on the sacrificial altar over the door, and the Christ Child worshipped on the altar within. The short side walls on either side of the altar recess are painted with singing angels, while above there were once the symbols of the four Evangelists. Only Matthew's angel and John's eagle now remain. Mark's lion and Luke's ox were destroyed when a window was cut into the wall. This window was removed when electricity was installed, but by then the animals had gone.

Like the Lamb, these four symbols are linked to the Book of Revelation and thus point to the end of time. They are often used to refer to the four Gospels, but they are no less importantly the 'beasts of the Apocalypse' who sit round about the throne of God in Revelation 4:7. As in the catacombs, therefore, the Magi of the Medici travel not only to adore the Child of the Nativity, but also to greet the Christ of the Second Coming – who will come in glory to judge.

The intended message of the painted decoration was spelled out by the priest Gentile Becchi, tutor to Piero de'Medici's sons: 'In Cosimo's chapel there were painted, in the first part the Magi, in the second angels singing, in the third Mary adoring her new-born, so that visitors might offer tribute with their hearts, with words and with works. The gifts of the Kings, the prayers of celestial beings, the intellect of the Virgin are the sacred things at this altar.'

The Magi still symbolize all humanity, but their scope has expanded in the

centuries since they were pictured in the catacombs; drawing on yet richer traditions of interpretations, Benozzo associates them with the three ages of man, the seasons, the times of day and the virtues. On the east wall behind which dawn breaks rides the youthful King Gaspar, dressed in white, colour of innocence, of spring flowers and of the theological virtue of Faith [PLATE 11]. On the south wall of noon rides the mature Balthazar, in the green of summertime foliage and of Hope. And on the now-incomplete west wall, where the sun sets, rides old Melchior, wearing the red of sacrifice, of autumn fruits and of Charity.

But if they are totally universal, these Kings are also very specifically part of the Medici world. Gaspar rides a horse whose trappings bear Medici emblems – entirely appropriately, since the family was bankrolling a great many fifteenth-century European rulers. The Magi in Cologne are joined by only one German monarch. But here Benozzo shows them with a whole company of rulers – a selection of princely Medici allies and no fewer than three generations of Medici themselves. We can recognize, from their portraits in other contexts, Sigismondo Malatesta, Lord of Rimini; Galleazzo Maria Sforza, Duke of Pavia; the elderly Cosimo de'Medici, his son Piero the Gouty and his youthful grandsons Lorenzo (later known as 'the Magnificent') and Giuliano. Riding behind them is the author of this magnificent pageant: Benozzo Gozzoli, who has proudly signed his work in golden letters on his red hat.

Despite the coherent theological framework of the chapel listed by Becchi, Benozzo has endowed the Magi's cortège with all the trappings of an aristocratic outing – an idealized version of excursions actually enjoyed by the Florentine rich. In a landscape somewhere between Tuscany and fairy land, the shepherds have now left the manger and are safely back with their flocks, surprisingly having taken the ox and the ass away with them. The countryside is shown, not as the site of a harrowing and dangerous journey, but as a place for noble exercise and pleasure. Never can the Magi's retinue have had such fun. The Kings seem to have set off as much for the delights of the hunt as for the journey to Bethlehem. Their pages carry the royal gifts, but their other companions have with them spears, crossbows and bows and arrows – dogs, falcons and hunting animals of all sorts. And some even break off from the procession to hunt their prey. The purpose of the journey may be of ultimate seriousness, but much pleasure may be had on the way.

It is hard, in front of all this material magnificence, to interpret the gold presented by the Kings to the Christ Child as 'the treasures of our mind' or 'the purest gold of a clean conscience', as contemporary preachers did in their sermons on Epiphany. But nor, I think, is it merely a celebration of wealth and power. It is

surely a joyful sanctification of the fruits of trade, at a time when Italian, Spanish and Portuguese trade was expanding the mental frontiers of Europe to encompass more and more of the world. And while nobody doubted the spiritual significance of the Magi's journey, it was the commercial value of their material gifts that drove traders and explorers to travel ever further afield – in search of incense, spices and above all, and always, gold. And they took the Kings with them.

Where the thirteenth-century Venetian traveller Marco Polo had reached the Far East by following, like Benozzo's kings, overland trade routes, the later explorers could travel on new ocean-going ships, which carried more men, arms and provisions than could any caravan of mules or camels. By 1500 Portuguese navigators had rounded the Cape of Good Hope to find the eastward sea route to India. Some twenty-five years earlier, however, the Genoese Christopher Columbus, advised by a Florentine astronomer, had conceived of reaching India more directly by sailing west. In 1492, after first applying to the kings of Portugal and of England, he finally persuaded the Spanish sovereigns, Ferdinand and Isabella, to finance his first Atlantic voyage.

All his life, Columbus believed that the islands he discovered on this and a subsequent journey lay off the east coast of India – he called them the West Indies. Only on his third voyage, in 1498, did he reach the mainland of a continent until then unknown to Europeans, later named after Amerigo Vespucci, the Florentine who followed in his wake: America.

In South America the explorers eventually found the gold and silver they had come to seek. But they also found, high in the Peruvian Andes, one of the most advanced empires in the world – and destroyed it.

In 1533 Francisco Pizarro entered the Inca capital, Cuzco, and seized it in the name of the Spanish crown and the Christian faith. The city was swiftly looted of its gold and brutally transformed, as the Spanish conquistadors and the priests and friars who had accompanied them set about building on the foundations of this unimaginably alien culture, a citadel of European Christianity. Cuzco became the centre of an enormous new diocese.

The new churches were, like European churches, filled with paintings to strengthen the faith of the newly converted Indians. The Spanish missionaries in Peru arranged for copies of the most up-to-date religious art of Spain, Flanders and Rome to be sent to America, and commissioned, from the few European artists who had emigrated, works designed to speak directly to the native population. The most startling example I know of this new exotic flowering of European religious paintings is in Juli – 12,000 feet above sea level, on the shores of Lake Titicaca, at the foot of mountains long held to be sacred.

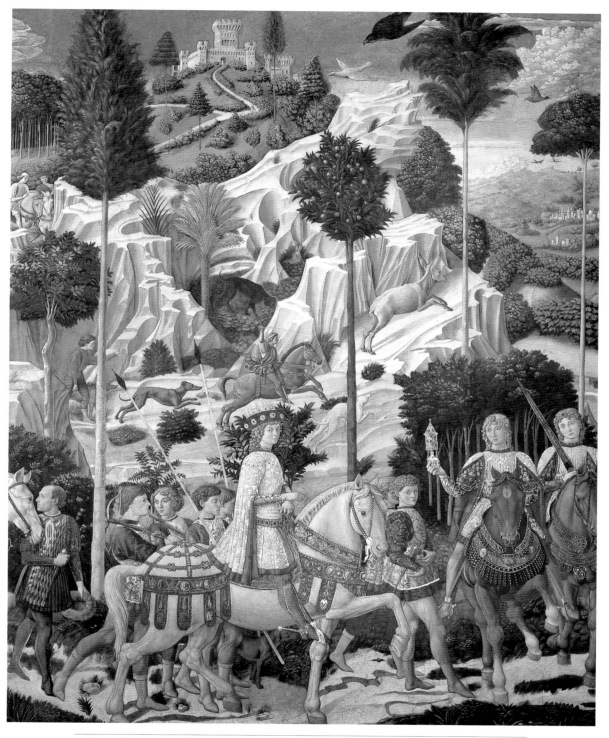

11 BENOZZO GOZZOLI *The Journey of the Magi*, detail of the east wall of the Chapel of the Magi, Palazzo Medici-Riccardi, Florence, 1459–61

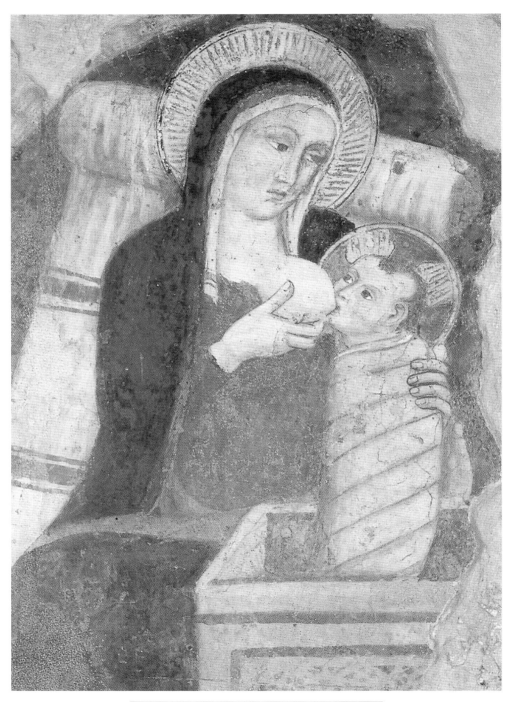

13 *Franciscan crib with the Madonna del Latte*, detail,
Franciscan sanctuary, Greccio, fourteenth century

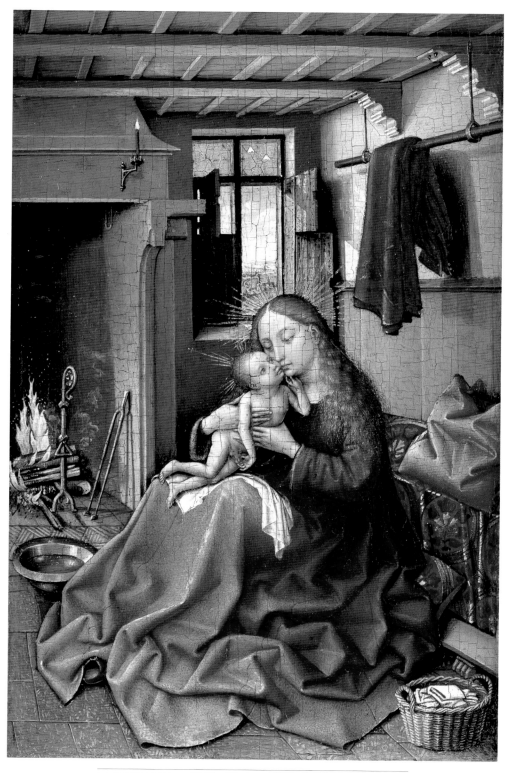

14 ROBERT CAMPIN (?) *The Virgin and Child in an Interior, c. 1432*

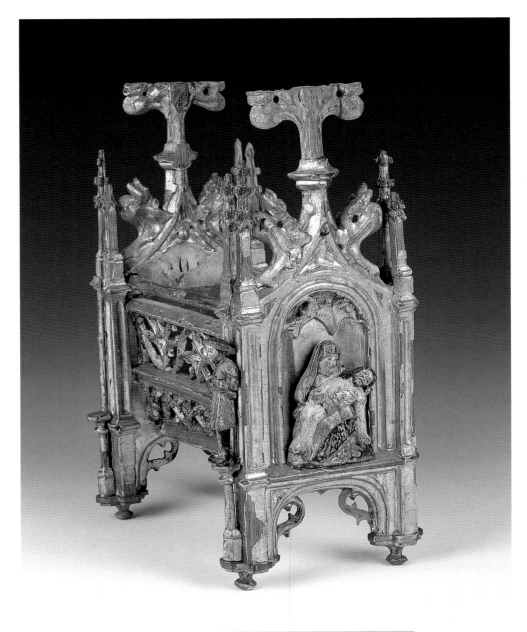

15 Unknown Netherlandish artist *Christ's cradle, c.* 1480–1500

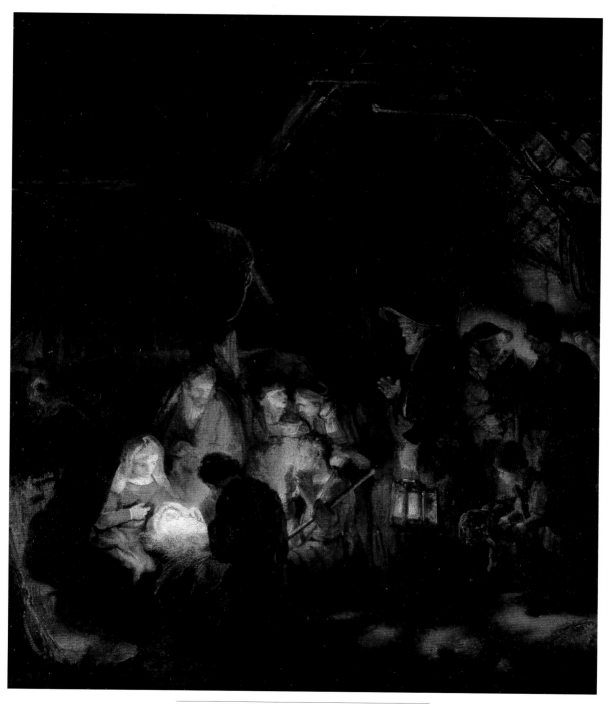

16 REMBRANDT *The Adoration of the Shepherds*, 1646

images. Religious imagery was not, as has sometimes been suggested, prohibited, but it was now, above all, intended as a means of instruction and a source of visual pleasure.

Like the Jews, the Protestant Dutch were essentially people of the Word. Their church services centred on sermons and readings from Scripture. They also read the Bible at home, translated into their own language, and pondered not only the New Testament but also the moral lessons to be derived from the Old – frequently identifying themselves with the people of Israel guided and rescued from slavery and oblivion by God. The earliest religious and moral teaching was expected to be given to children at home by their mothers, and in this task pictures on the walls could play an important part.

We do not know, of course, whether Rembrandt's *Adoration* was ever expounded to children, but it is not hard to imagine. This is the night of the birth of Christ; the first Christmas. In the dark recesses of a real working Dutch barn, the ox and the ass gently ruminate. Mary and Joseph are receiving the visitors who have come to revere the new-born child; the shepherds have brought their wives and children with them, perhaps an old granny or two. They look in some ways more like Dutch fisher folk than shepherds. But they are clearly country people, and all are well wrapped against the bitter winter cold.

The baby lies swaddled and snug in the warm hay, glowing like the brightest of lamps. His light eclipses that of the visitors' lanterns.

Above the Holy Family, the struts and beams and ladder of the barn form a sturdy vertical star shape, with a winnowing basket in its centre. And here, if we wish, we can discern symbolic meanings that Rembrandt may have intended to enrich our viewing. The arrangement of straight lines recalls the early Christian monogram, in which the first two Greek letters of Christ's name, the X-shaped Chi and the P-shaped Rho, are superimposed [PLATE 19]. It was, as we shall see, an emblem used in the first centuries of the Church, and later by the Emperor Constantine and his successors. The basket itself suggests various appropriate associations: a winnowing basket is used to separate the wheat, which will be stored, from the chaff, which will be burnt, as Christ on his return will judge us (Matthew 3:12; Luke 3:17); the Jews were commanded to offer the first fruits of the harvest to God in a basket (Deuteronomy 26:2) and Christ will become the first fruits of them that sleep; and the infant Moses, who later brought Israel the law, as Christ will bring grace, was saved from the waters in a basket of bullrushes (Exodus 2:3).

But nothing compelled even seventeenth-century Dutch readers of the Bible to analyse the picture in this way, and nothing compels us now. The small, friendly

canvas, with its warm earth tones, its rough texture, its freely brushed paint, goes straight to the heart. The shepherds – among whom it is hard to find any sheep – are people like Rembrandt's family and their neighbours, and by extension like us: good-hearted northern people gathered on a dark, cold and damp December night to welcome the new-born baby for whom there was no room at the inn. And when the shepherds had seen him, says the author of a medieval book of meditations, 'they went on their way rejoicing'.

The Franciscan crib tradition expanded to encompass all, and all sorts, of life, enabling us to visualize and participate in the mystery of salvation. Its extraordinary achievement has been to involve everybody, not just shepherds and kings, but people from every part of society to play their role in the story of the birth of Christ.

Yearly on Christmas Eve, the people of Greccio relive the moment when St Francis set up the Christmas crib among them. A costumed procession makes its way by torchlight from the town square to the Franciscan sanctuary with its hallowed grotto. On the mountainside – for the grotto is now too small, too enclosed by buildings, to accommodate everyone – a pageant with actors and a living ox and ass re-enacts Tommaso of Celano's account, closely following the thirteenth-century text. The sets are made at Cinecittà, Italy's film production centre in Rome, and many hundreds of people come to watch.

Across the world, even if Francis's role in the Christmas tradition has been more or less forgotten, Christmas processions and Nativity plays are staged everywhere. Churches and families at home set up miniature panoramas of the crib, some with entire landscapes through which figures of shepherds and kings pass: deserts, mountains and grottoes, cities and countrysides teeming with life, with every trade and condition of mankind represented in minutely realistic contemporary detail. The most elaborate and the most famous of these cribs were made in eighteenth-century Naples for the instruction and entertainment of the court, and we now find them proudly exhibited in museums as far away as New York.

But there can be few places where the crib tradition remains more alive than in the old Catholic towns of southern Germany. In Bamberg, for example, you frequently have the impression that the figures from the Christmas story have taken over the entire town. People throng Christmas markets, where religious figures, ornaments, mulled wine and gingerbread are sold cheek by jowl, marking a festival that is at once civic, religious and straightforwardly commercial. Outdoor cribs show, one after another, the episodes surrounding the birth of Christ, beginning with the very moment of the Incarnation, when the Angel Gabriel appears to Mary to tell her that she will bear the son of God.

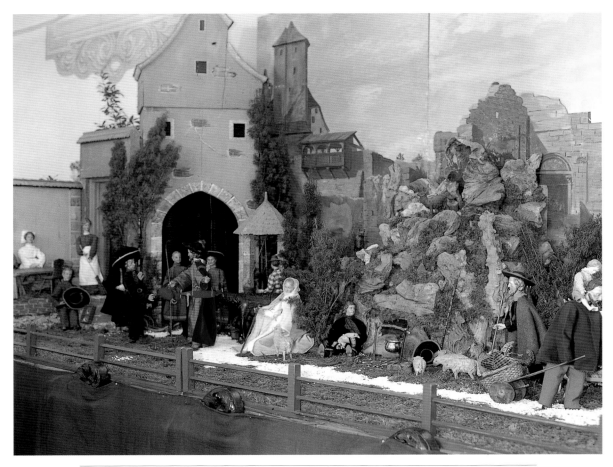

17 *Christmas crib*, detail, Obere Pfarre Church, Bamberg, figures eighteenth and ninetenth century

The finest of Bamberg's cribs is, without question, the one in the church of the Obere Pfarre, where eighteenth- and nineteenth-century figures tell the story as it might have happened in Bamberg itself [PLATE 17]. The angel appears to Mary, who lives not in an ordinary, half-timbered house, but in a smart stone pavilion, very much like one that can still be seen a few hundred yards away on the Michelsberg. Adoring the new-born child are identifiable local characters, among them a celebrated Bamberg horseradish seller.

Yet if everything is happening in the same place, it is certainly not happening at the same time. In front of the stable where the Three Kings have left their horses, summer corn is being threshed, and fruit and flowers, for which Bamberg's market gardens are still famous, are being sold – because the events of Christmas touch daily life at every season of the year.

The cribs of Bamberg have been called 'a meditation for the eyes'. What they teach is that there is no need for us to struggle to Bethlehem like the Peruvian chieftain, because Bethlehem is where we live. The stable is in our town, Christ is being born now, here, and we should pay attention.

What Francis achieved was the most astonishing act of public education. Different texts of the Bible drawn together, their meaning elaborated over the centuries of theological discussion, have become something visible and under-standable, livable as an act and a fact by everybody of whatever level of belief, education and age. But what we have lost in our sentimentalizing, commercializ-ing and trivializing of the Franciscan tradition is something which Francis himself, with his tears of pity and love for the crucified Christ, his mixing of the crib and the tomb, never forgot: the sheer horror of the Incarnation, of God born in order to be put to death by men.

PIETER BRUEGEL THE ELDER
The Adoration of the Kings

To paint the infant Christ at any date is to take a view of the nature and purpose of his birth, for this most simple and familiar of subjects is infinitely rich in meaning. In the hands of a great artist it can move us and teach us, carry the most cynical political ambitions, or the subtlest meditations on the love of God. I should like to close this section by looking closely at another *Adoration of the Kings*, painted by Pieter Bruegel the Elder [PLATE 18]. It hangs in the National Gallery, London, opposite the Gossaert *Adoration*, with which we began. And it is indeed an opposite in many more senses than that.

This painter of the robust labours and pleasures of peasant life, of proverbs and country landscapes, was after his death believed to have been a peasant himself: 'Peasant Bruegel', 'Droll Bruegel'. This was fantasy. He was, in fact, an educated and well-travelled man, in touch with the artistic and intellectual innovations of his time. His work was collected by some of the richest and most highly educated people of the day. But in his works, he wore this culture with an off-hand ease, and could exploit a sometimes savage humour to present universal truths with a contemporary twist. Bruegel's topical references to popular theatre and religious processions, local Flemish folklore and proverbs, and satirical prints, some of which he himself designed, can make much of his work seem enigmatic to us, and rarely more so than in this picture. We do not know for whom, or why, it was made.

Bruegel's *Adoration of the Kings* is signed and dated 1564, a year after the artist had moved from bustling, cosmopolitan, commercial Antwerp to aristocratic Brussels, seat of government, and a centre of tapestry weaving. Raphael's famous tapestry designs for the Sistine Chapel in the Vatican (now in the Victoria and Albert Museum, London) had been sent there to be woven, and all but one were still there when Bruegel arrived. The *Adoration* may well have been influenced by Raphael. The figures crowd the composition, which echoes the central Epiphany scenes of older Netherlandish art, as do the costumes of the Three Kings – compare, for example, the soft riding-boots of the black King Balthazar with

those of his counterpart in Gossaert's altarpiece [PLATE 1]. But the rich exotic retinue of Gossaert's Kings, with their courtly pages and train-bearers, their horses and camels, is totally absent. And strangely for Bruegel the landscape painter, there is no hint of surrounding countryside: just an oppressive throng by the wooden shed where the Kings present their gifts. There is no weather, no time of year: Joseph's straw hat, that provides a sort of halo for the Virgin, seems more appropriate for summer travel than in December.

Equally unsettling is the totally contemporary air of the curiously prominent soldiery – an archer with an arrow stuck in his hat and a band of rough-and-ready halberdiers – and the civilian onlookers. One of these whispers in Joseph's ear; another ogles Balthazar's gorgeous censer – part nautilus shell, part crystal globe, part golden ship – through round-rimmed glasses.

Most equivocal of all is the ugliness of all the participants except for the Virgin and the Christ Child. We seem to be looking at caricatures of fallen humanity. The soldiers, like the townsmen, have eyes only for the Kings' treasures; even Joseph may be assessing their material worth. And the Three Kings appear not to have humbled themselves before the King of Kings: humiliated by the painter's brush, they have been made grotesque examples of earthly pomp that requires armed battalions to keep it in power.

We sense that our unease is shared by the Child himself. The open dish proffered to Christ by the oldest king seems to hold, not gold, but granules of myrrh resin used for anointing the dead. While Gossaert shows us the Child King, Bruegel shows us the Child born to die. The gift tells the future, and he recoils, shrinking back in to the protective arms of his mother.

At the time Bruegel was painting this *Adoration*, terrible trouble was brewing in the Low Countries. The Emperor Charles V, King of Spain and lord of the Netherlandish provinces, had in 1555 abdicated in favour of his son, Philip II. Unlike Charles, who had been born and brought up there, Philip had no natural links with Flanders; he was Spanish through and through. In Brussels, Spaniards were elbowing Netherlandish nobles out of the high councils of state. More and more taxes were forcibly exacted by central government from towns and villages, with property and crops confiscated in default of payment. Many had broken away from the Roman Church to embrace various forms of Protestant belief; these 'heretics' were pursued with torture and death, in disregard of civil and civic rights long held sacred. Although most Netherlanders remained Catholic, there was a general sense of revulsion against the harsh edicts, the persecutions and bloody executions of Protestants carried out by bureaucrats and soldiers in the service of the king. In 1559 Philip departed for Spain, leaving behind him his able

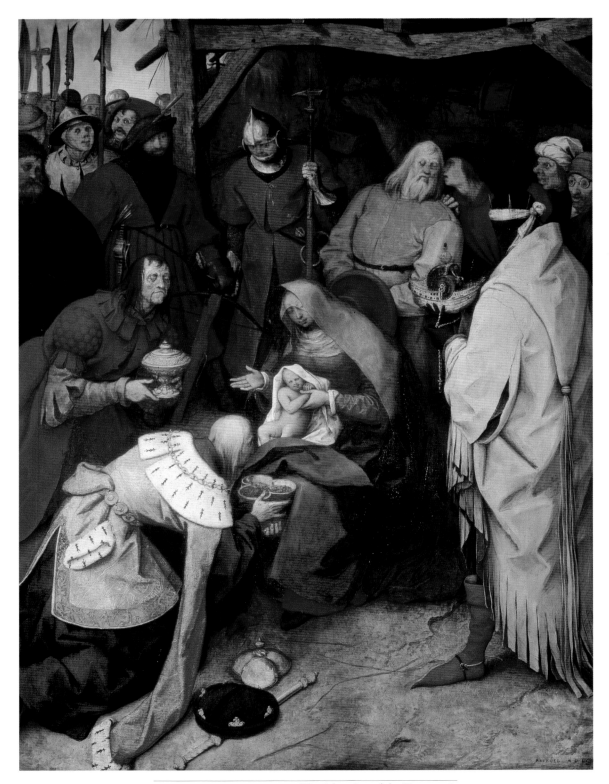

18 PIETER BRUEGEL THE ELDER *The Adoration of the Kings*, 1564

half-sister, Margaret of Parma, as regent, but with intransigent Spanish officials to keep her in place – and a disaffected clergy, nobility and populace.

On the last day of 1564 (the year in which the picture was made), William, Prince of Orange, at that time still a loyal subject and a Catholic, addressed his fellow Netherlandish noblemen: 'The king goes astray if he thinks that the Netherlands, in the midst of lands where freedom of religion exists, can continue to endure the blood-stained edicts … No matter how strongly I am attached to the Catholic faith, I cannot approve of princes who wish to govern the souls of their subjects and to deprive them of their liberty in matters of conscience and religion.'

Two years later, in 1566, groups of zealous Protestants broke into churches and convents throughout Flanders, destroying religious paintings and sculptures. Philip responded by sending an army under the Duke of Alva, who was given unlimited power to subdue the country and reinstate the Catholic religion by force of arms. The 'Spanish Fury' that sacked Antwerp, and massacred eight thousand of its inhabitants, was soon to be unleashed. By the end, many other cities had been destroyed; Alva would boast that he had killed some eighteen thousand people; many more fled into exile. The rebellion would eventually lead to the break-up of the Spanish possessions in Northern Europe, and the formation of an officially Protestant state, the Dutch Republic.

I am not claiming prophetic powers for Bruegel as he painted this picture. Yet it is clear that much of what was to come was already in the air, and that the *Adoration of the Kings* refers to it. In the Franciscan spirit, he located Christ's birth in the Low Countries and in his own time, using the idiom of the Bible to paraphrase the travails of his own land. The ass in the stall – there is no ox – knows his master; like Balaam's ass, he has eyes to see the Angel of the Lord (Numbers 22:21–34), while those who are blinded by cupidity and illusory earthly power, and need glasses, remind us of the 'rebellious house' lamented by Ezekiel: 'Son of man, thou dwellest in the midst of a rebellious house, which have eyes to see, and see not' [Ezekiel 12:2].

Far from Christ welcoming the kings and acknowledging their royal fellow-ship, we feel that the opposition between him and them is complete. Their escort is made up not of courtiers, but of brutal soldiers. And, a few verses later in St Matthew's Gospel (2:12–16), soldiers like these, acting on the orders of another king, Herod, will kill all the boys in Bethlehem under two years of age, to eliminate the threat that the new-born Jesus poses to the established order. Their first gift is not the 'purest gold of a clean conscience', but the myrrh of death. No wonder the Christ Child recoils.

It is a profoundly subversive picture.

PART TWO

THE QUESTION OF APPEARANCE

I am the good shepherd,
and know my sheep,
and am known of mine.

JOHN 10:14

CHAPTER FIVE

SIGNS AND DEEDS

We have mainly been looking so far at images of Christ as a baby. Now it is a sad fact that for most of us, one baby looks very much like another and indeed their specific appearance is generally of absorbing interest only to their near relations, who scan the features looking for resemblances to one or the other side of the family. And that, in essence, is the perennial problem for artists portraying Jesus Christ at any stage of his life: how to show him at one and the same time as his mother's son – fully human; and his Father's – fully divine.

The problem is not acute when he is represented as a baby in Christmas or Epiphany scenes: context is all. He may appear naked or swaddled, or dressed in a Roman toga. He may lie in a manger, or upon the ground, or sit enthroned on his mother's lap. He may be adored by rich and poor, black and white, by wise men or by kings, by shepherds, by women and children and by angels. He may reach out for an offering, or recoil from a portent of death. He may, as in early Christian art, have the proportions of a miniature adult [PLATE 8], but the point is that he is *miniature*; what his face looks like does not matter. He is in fact shown as *any* baby, and artists have devised other means to let us recognize his true nature – the animals of Scripture, the gifts of the Kings, the manipulation of light tell us that this is not just a child but the Messiah. And when it came to representing Jesus the grown man, the teacher and worker of miracles, the Saviour, they initially went about it in the same sort of way.

The earliest Christian art evolved, as we have seen, in a milieu suspicious of imagery; and at the beginning, Christ was represented not through images but in signs, which we first find scratched on funerary slabs, and which soon spread from catacombs and marble sarcophagi to everything: seals, jewellery, lamps and other household objects. As we might expect in a society of mostly Jewish-born converts, these signs depend on words and word games. A monogram was formed from the first two Greek letters for the word Christ, the Chi Rho already mentioned [PLATE 19]. It had long existed among the pagans as an abbreviation of the similar Greek word *chrestos*, meaning 'auspicious', and had been used as a

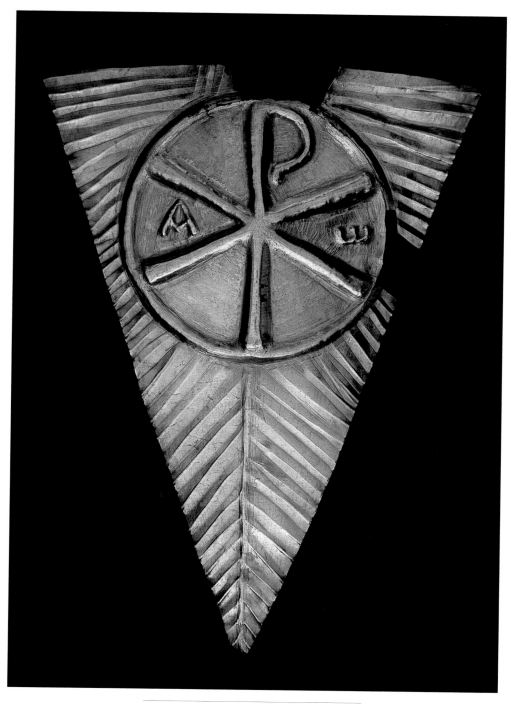

19 Votive plaque with Chi Rho, fourth century

Fish had another obvious Gospel association, recalling the first disciples' occupation as fishermen, and Christ's summons: 'Come after me, and I will make you to become fishers of men' (Mark 1:17). By happy coincidence fishing scenes, which offered pleasing opportunities to paint expansive landscapes, were already extremely common in the decorative art of pagan Rome; now they were readily transposed to the Christian catacombs, where they signified the apostolic fishermen, catching *pisciculi* to be baptized and saved.

We can see from this single example of the fish-sign that, in a Roman culture rich in imagery and artists, it would have been difficult for any purists hostile to images to hold the line. The initials of a simple declaration of faith – Jesus Christ, Son of God and Saviour – became a word, the word a sign, the sign an image – and the image was then woven into entire stories. Once signs were admitted, a whole pictorial repertoire would follow. But it was a repertoire not of Christ's likeness, but of aspects of his nature, and it was also word-based, drawing on the vivid verbal imagery of scripture which could easily be translated into pictures. Most of it remains perfectly familiar and perfectly understandable today.

Vines heavy with bunches of grapes twine through early Christian decoration in every medium [PLATE 21; see also PLATE 4]. They are an image of the Saviour who said of himself, 'I am the true vine' (John 15:1). And as he is the vine, the faithful are the branches, so this is also an image of the Church. Encyclopedias could be compiled on the Christian imagery of vintage and wine-making, referring above all to the wine of the Eucharist (which in turn harks back to the wine of Old Testament rituals). Here again, there was a rich tradition of pagan decoration to draw on, for not only did the pagans use wine in their religious ceremonies and sacrifices, but the Greek and Roman god of wine, Dionysus or Bacchus, was also a deity believed to have died, been buried and risen again. Vines, grapes and all that went with them adorned both pagan and Christian tombs as a hopeful sign of life after death. The Christian tombs can usually be distinguished by wreathed Chi Rho monograms combined with the scrolling vines, sometimes shown growing out of an amphora, the two-handled wine jar of the ancient world.

But perhaps the most popular scriptural metaphor to be translated into images by the early Church was that of the Good Shepherd. The consoling verses of Psalm 23 had long been known and loved:

The Lord is my shepherd; I shall not want.
* He maketh me to lie down in green pastures: he leadeth me beside*
the still waters.

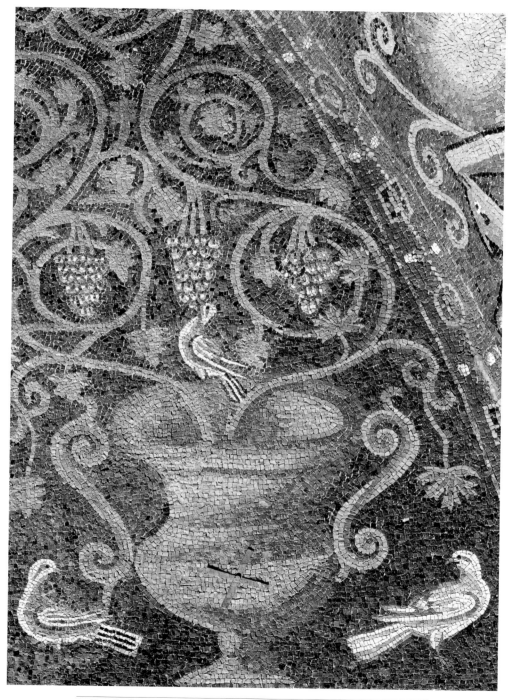

21 Detail of grapevine and birds, apse mosaics, San Vitale, Ravenna, *c.* 547

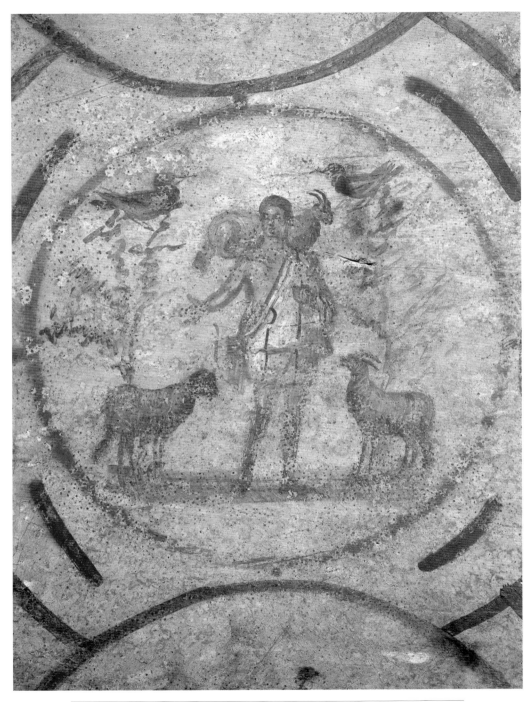

22 *The Good Shepherd*, vault of Capella Greca, Catacomb of Priscilla, Rome, *c*. 250

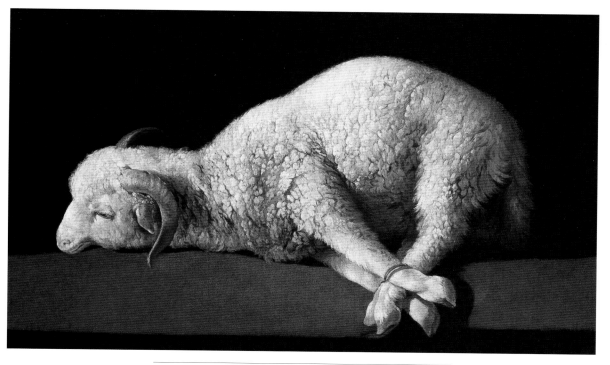

23 FRANCISCO DE ZURBARÁN *Bound Lamb* or *Agnus Dei*, 1630s

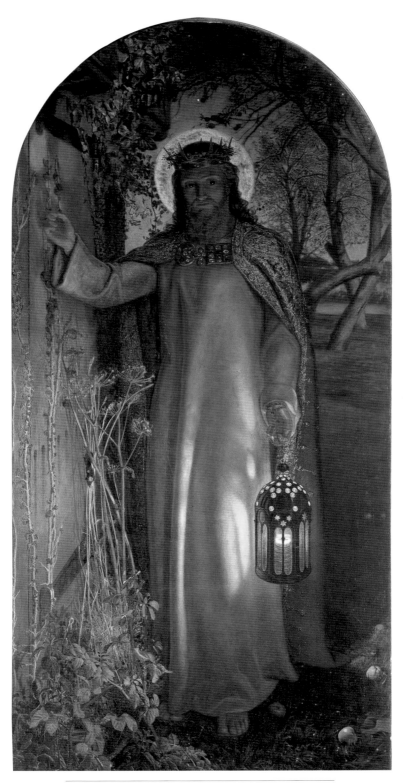

24 WILLIAM HOLMAN HUNT *The Light of the World*, 1853

the smart toga of a Roman gentleman. In the scene of the Raising of Lazarus, which appears again and again in Christian burial places, the small shrouded figure of the dead man rising up in his tomb can only be Lazarus, and so we know it can only be Christ who calls him forth. A man carrying his bed on his back can only be the healed paralytic, so the well-dressed person gesturing to him must once again be Christ.

The painters of these subjects, like the unknown catacomb artist in the Capella Greca *Adoration of the Magi* [PLATE 3], were not aiming to illustrate the life of Christ, but to show his divinity. His miracles were included as instances of divine intervention. The invisible God of the Old Testament acts through angelic or human agents, as in the stories of Abraham and Isaac, Moses striking the rock, and Susanna; he remains invisible even when intervening to save Jonah from the whale or the boys in the burning fiery furnace. The New Testament God, made man in Jesus Christ, acts visibly and in his own person. Unlike the patriarch Abraham with his long white beard, he is clean-shaven, the stereotype of a youthful Roman, because as a man he did not survive into old age. What was important to this community of believers was not what he looked like, but what he had done – heal the paralytic, raise Lazarus; and what he would do in the future – like a good shepherd, care for us, seek us out and save us. At this stage of Christian art, every Christ looks different. It is his acts, not his appearance, that allow us to recognize him for what he is.

It is a convention of disregard for likeness that was to last for centuries. Armed with early Christian images of the face of Christ as the Good Shepherd, Christ raising Lazarus or healing the paralytic, you could not possibly recognize this man if you bumped into him out of context, or even if you went specifically to meet him off a train at Victoria station.

The stirrings of concern over what Christ actually looked like arose in large measure from the problem of his dual nature. For the earliest Christians, as for Christian churches today, Jesus Christ was the second of three persons making up one God – the Trinity of Father, Son and Holy Spirit – and was therefore at once divine and human. This concept is so difficult to grasp that, as Christianity was emancipated, then became a state religion, theologians increasingly tried to define it according to the rules of secular logic. What was the balance between Christ's human and divine natures? Was the balance between them constant? How could they be recognized? Many hairs were split. Councils of the Church were called, attended by bishops and clerics from most or all of the Christian sees, to formulate a creed acceptable to all; but they frequently revealed, indeed even fomented, dissent, as different opinions were voiced until the definitive statement of Christ,

fully human and fully divine, was formulated by Pope Leo the Great at the
Council of Chalcedon in 451.

Of the many heresies on this inexhaustibly complex topic, the most widely
disseminated, the longest lived, and the one that most affected visual art
was Arianism, the doctrine of the fourth-century Libyan theologian Arius.
Condemned at the Council of Nicaea summoned by the Emperor Constantine
in 325 (which gave us the Nicene Creed), Arius's teachings became after
Constantine's death the accepted doctrine in much of the Greek part of the
Empire, and from there spread to the Germanic tribes in Central Western Europe.
The heresy never took hold among the Latins in Italy, but as the Germans invaded
the peninsula, they carried their Arian beliefs with them – and they illustrated
them in spectacular works of art.

Arius maintained that God, who existed without beginning, created the Son
out of nothing, even before the creation of time. 'Every one knows ... that the
Father is greater, the Son subject ... that the Father has not a beginning, is invisi-
ble, immortal and impassible; that the Son is born from the Father, God from
God, light from light ... that from the Virgin Mary [the Son] took man, by means
of which he shared in suffering.' Very crudely resumed, the Son of God was not
eternal, not God by nature; his divinity was conferred upon him. If this is hard to
understand, it is easier to see in the mosaics of the great churches of Ravenna.

In common with other Germanic tribes, the Ostrogoths who conquered
Ravenna in the fifth century had been baptized as Arians. They cohabited peace-
fully, but as distinct nations, with the local Latin Christians; each community had
its own tribunals and laws, and throughout most of Theodoric's reign each enjoyed
full religious autonomy. The king naturally ensured that his Arian people had their
own places of worship, whose decoration would express the doctrines of their faith.

The mosaics of Theodoric's Arian church of Sant'Apollinare Nuovo run
along either side of the nave – and thus they offered the perfect twin vehicle for
artists wanting to distinguish the two (for the Arians) separable natures of Jesus
Christ, human and divine. The sides of the nave were already differentiated by
gender: during services, women stood on the north side and in the main register
of decoration above them, female saints are led by the Magi to adore the Christ
Child in the Virgin's lap [PLATE 8]. Men stood on the south side, below a proces-
sion of male saints, going forward to worship the adult Christ, the King and
judge. Above this register, in a series of small scenes, the artists tackled what was
for them the key issue about the image of Christ: not his likeness, not the story of
his life, but what was made manifest in his life. On the one side, we see Christ
preaching and healing, on the other are the scenes of his Passion.

The miracles and the teachings reveal his divine nature, but it is as a man that Christ is betrayed, judged and led to his death. And, startlingly, each nature has a different physical appearance. Like the Christ of the catacombs, he is youthful and clean-shaven when divine, but he is older, and bearded as a Palestinian might have been, when his human nature is being emphasized [PLATE 38].

The mosaics of Sant'Apollinare Nuovo are not biography and even less are they portraiture. Rather, they are a visual Christology, a study of the essential nature of Christ. After the king who commissioned them had died, the Byzantine Christians who took over the church effaced his likeness and that of his courtiers. The political power of the Arians was thus eliminated. But they did not destroy these mosaics, perhaps because they found them too beautiful, perhaps finding ultimately acceptable their representation of the dual nature of Christ.

Sant'Apollinare Nuovo represents a magnificent theological and artistic achievement: a formula for holding in balance the two aspects, human and divine, of Christ's nature, visible at different moments in different events. But there is a moment in Christ's earthly life when the two natures have to be equally visible at once: the Baptism, when John the Baptist saw the Holy Spirit descend on Jesus. In the dome mosaic of Theodoric's Arian Baptistery, it posed the artists a huge problem – how to show a man both human and divine. To solve the problem, the artists exploited – one might almost say ransacked – the vocabulary of pagan sculpture [PLATE 25], although, of course, in view of the Church's continuing fear of idolatry, translating it into a two-dimensional medium.

The River Jordan sits on the left – in the form of an ancient Roman river god with his symbolic rush sceptre in his hand and an improbable crayfish headdress. In the middle, up to his waist in water, completely naked, stands Christ. The artist has wanted to show that he is not just a man, and he looks uncannily like a statue of a youthful pagan divinity, of the sort you can still see in Rome: the statues of Castor and Pollux now on the Capitoline Hill, half human and half divine, may have seemed natural models to turn to. What other language, indeed, could the artist have used? On the right, even John the Baptist has not escaped the touch of paganism, for he does not wear the biblical camel skin, but has borrowed the leopard skin of the old god of wine, Bacchus.

We are not shown the Baptism by water. John merely touches Jesus's head with his hand: it is the Spirit, which pours down from the dove, which confers divinity. The Arian beholder can watch the human nature of Jesus being made divine.

To see where the dove comes from, we must turn around and change our point of view. When we walk to the other side of the Baptistery and look up, we

find an imperial throne lavishly jewelled and empty save for a purple cushion on which stands the glorious Cross of Christ's triumph over death [PLATE 37]. This is the emblem of God, for we on earth cannot yet see God face to face. It is towards this invisible presence that Paul holding his Epistles and Peter with the keys lead the Apostles, all dressed like Roman senators and holding victors' crowns.

The dome of the Arian Baptistery is a dazzlingly subtle piece of visualized theology. We cannot see God, but when we have changed our point of view we can behold the Son of God incarnate on earth, his divine nature manifest in the only form the artist at this date had at his disposal: that of a pagan divinity. It is also the clearest possible demonstration of the continuing tension between the Jewish-derived tradition of a God that must not be represented, and a pagan culture accustomed daily to seeing its gods in images displayed throughout its cities.

25 (OPPOSITE) *The Baptism of Christ, the Apostles and the Empty Throne,*
dome of the Arian Baptistery, Ravenna, 493–526

26 *Acheiropoieton,* or 'image not made by human hands',
icon *c.* 600, silver casing, *c.* 1200

THE QUEST FOR
THE TRUE LIKENESS

At Ravenna, the conflict between the desire to see God and the fear of representing him had (just) been held in check. But beyond the sea in Constantinople, it intensified steadily, eventually erupting into open warfare.

The political situation in the East was grave. Egypt and Syria had been conquered for Islam in 681. The heartland of the Byzantine empire was threatened by continuous raids of non-Christian nomadic tribes – Slavs and Bulgars as well as Arabs. In the Balkans religious and educational institutions, more closely identified with the imperial court than in the Latin empire, were in disarray. Christianity, as practised by a demoralized population, was in danger of becoming a miscellany of debased superstitions. Many found it intellectually and morally inferior to Islamic monotheism, with its firm insistence on holy writ and a strict taboo on images.

The situation was saved, or so it seemed, when in 716, a Byzantine general from Isauria in Asia Minor seized the Byzantine crown, assumed the imperial throne as Leo III, and in 718 repulsed a formidable attack by Islamic Saracens. In 726 he issued an edict prohibiting the use of images in public worship. Throughout the Eastern empire, mosaics and pictures were smashed. A fleet was despatched to the harbour of Ravenna, with instructions to destroy the mosaics there. Luckily – from the point of view of Western art – that particular fleet never arrived.

The appearance of the Iconoclasts, or Image-breakers, in Italy stirred the local population to ferocious resistance. The Byzantine-held cities rebelled; and in 728 Ravenna was lost to Byzantium. In Rome, Pope Gregory II denounced Leo's edict, and the controversy over images split Christendom and divided the Byzantine empire for over a century.

Byzantine iconoclasm, several times condemned as heresy and repealed, was not finally defeated until 843. Since then, both Eastern and Western churches have admitted images. But the passions the dispute aroused profoundly and enduringly affected the way both churches thought about representing Christ.

The main argument in favour of representation asserts that, because God had chosen to make man 'in his image', it must be permissible for men in their turn to make images. Since Christ was incarnate as man, it was proper to show him as a man. And as man's image already reflected God's, an image of the incarnate Christ showed him as both human and divine. 'From physical signs,' averred the champions of images, 'we are led to the contemplation of spiritual things.'

In Rome, where this argument seemed particularly persuasive, there was a long tradition both of images of the gods and portraits of the mighty – and in a city now ruled by the pope in Christ's name, it must have seemed unimaginable that no portrait of the supreme authority should exist. But there were, of course, no contemporary portraits of the Jewish-born Jesus, and the Gospels gave no indication of his appearance. How could this difficulty be got round?

Half the answer can be found in a chapel in one of the oldest churches in Rome, Santa Maria Maggiore, and, as you might expect, it begins with a legend. It is said that the Virgin Mary, while still nursing the Christ Child, sat to St Luke for her portrait. St Luke, the physician Evangelist, would, like all doctors of the day have had access to drugs, spices and pigments, and thus it seemed entirely likely that he should also have practised as a 'Sunday painter'. This was, of course, a story that particularly appealed to painters. On the strength of it, they chose Luke as their patron saint, while the holy portrait-sitting itself became an extremely popular subject in Western art.

Pictures of the Virgin and Child that came to the West from the Eastern empire were often identified as portraits by St Luke himself. There were many of them, but none enjoyed a greater celebrity than the silver-cased, heavily repainted image now in the basilica of Santa Maria Maggiore, so venerated that in the nineteenth century it received the title of *Salus Populi Romani*, the Salvation of the Roman People. For centuries, every year on 15 August, the day on which the Roman Catholic Church celebrates the Virgin's Assumption into Heaven, this much revered image came out of her church to welcome an effigy of her son. She was said to stir in her chapel the night before; and when they finally met, the two images solemnly bowed to each other.

The image of Christ that was carried in procession through the streets of early medieval Rome to meet his mother has been known since the eighth century, and still survives, although it has been venerated almost to extinction [PLATE 26]. The *Acheiropoieton*, or 'image not made by human hands', is housed in what was once the popes' private chapel in the Lateran Palace, a place furnished with so many relics that it is for this reason called the Sancta Sanctorum, the Holy of Holies.

27 Unknown artist *Mandylion of Edessa with Scenes of the Legend of King Abgar,* eighteenth century

In both versions, as you would expect, the miraculous image – not made of 'earthly colours' – performs miracles. It heals King Abgar and many others. It preserves the city of Edessa, converted to Christianity, from harm and from attack; and finally, after many miraculous adventures, it is brought to the emperor's court in Constantinople, where it became the object of the most fervent veneration.

At various points in the legend, the image imprinted on cloth by Christ himself miraculously replicated itself on other supports. These miraculous replicas being in turn replicated by artists, the likeness continued to multiply, the relatively unvarying formulae of Byzantine art guaranteeing, for the faithful of the Eastern Church, its authenticity to this day. The original Mandylion disappeared from Constantinople during the Crusades, to reappear around 1240 as one of the relics in King Louis IX's Sainte Chapelle in Paris, from where to vanish for ever in the church-hating relic-smashing violence of the French Revolution. But the Mandylion image, the likeness of Christ it had made familiar, marched on through the Orthodox world – indeed literally so, for it was reproduced on the banners carried by the armies of the Russian tsars until the early twentieth century.

Early copies of the Mandylion were brought or sent as gifts to the West and a particularly impressive one is still being held in Genoa. Ownership of so prestigious a relic conferred great status on Byzantium and the Roman Church was, not unnaturally, eager to have its own authentic likeness of Christ imprinted on a cloth by his divine agency. Fortunately – perhaps miraculously – some time around 1200 a cloth in St Peter's, long believed to have been used by Christ during the Agony in the Garden to wipe the sweat from his brow, was found to have his features impressed on it: it was given the name of the *Vera Icon* or True Image, and a garbled version of this name, Veronica, was bestowed on the woman by whose action, according to a new legend, the image had come into being.

The story of Veronica, the woman who took pity on Christ on the road to Calvary and wiped his face with a kerchief, is familiar to us from the innumerable works of art it inspired [PLATE 28]. But this story is a latecomer; it was written down only about 1300, probably first in France. Before then, legends circulated of a pious woman friend of Jesus's, Berenice or Veronica, who desired to have his portrait. By various miraculous means, which recall the origins of the Mandylion, her wish was ultimately granted. Sometimes Veronica is identified with the woman with an issue of blood, said in three of the Gospels to have been healed by Christ. In her gratitude, the legend goes on, she erected a bronze statue of Christ, and sent the miraculous likeness he had impressed on her kerchief to the Emperor Tiberius to cure him of leprosy.

Our Veronica, the one in this painting, is the creation of a slightly different

28 RIDOLFO GHIRLANDAIO *Procession to Calvary, c.* 1505

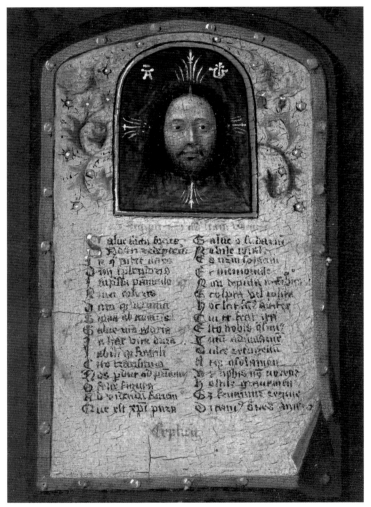

29 (ABOVE LEFT) PETRUS CHRISTUS *Portrait of a Young Man*, 1450–60
(ABOVE) Detail showing *Veronica Image and Prayer*

30 Volto Santo, Cathedral, Lucca, eleventh century?

(to be rediscovered again, and re-enshrined at the Vatican, although its image is said no longer to be visible) the loss was of the same order as the loss of the Mandylion: a relic was gone (and for pilgrims that was grave) but the likeness remained, and the fervour of the prayer it could arouse was undimmed.

While the Mandylion and its progeny remained the one authentic portrait of Christ in the East, the Veronica, although the most widely promulgated and the most influential, was not the only miraculously made True Likeness venerated in the West. Any old Byzantine icon was liable to be thought miraculous in origin, and we can still find them enshrined in churches throughout Europe, even in Rome itself. But there is one exceptional Eastern work, probably made in Syria – and certainly not in Constantinople, where monumental three-dimensional images were not tolerated – whose renown in the West for many centuries matched that of the Veronica. It is known as the Volto Santo, or Holy Face, of Lucca, despite the fact that it is a full-length life-size figure, sculpted in wood, of the crucified Christ [PLATE 30].

The fame of the Volto Santo originated in the fact that Lucca was a favourite stopping place on one of the main pilgrimage routes to Rome: the ancient Via Francigena or Romea, which linked Rome via France to the North Sea. One of the most welcome of its eighty staging posts must have been Lucca, lying on a fertile plain beyond the dangerous passes and torrents of the Tuscan-Emilian Appenines. Pilgrims rested there from an exhausting journey, and each of the town's many churches had its hospice to receive them. But what really detained the pilgrim was Lucca's miraculous Christ, today enclosed in a graceful wrought-iron Renaissance shrine in the cathedral of San Martino, where the statue is almost hidden under rich ornaments. It was more accessible to view – and to touch – in the Middle Ages, when there was only a crown on its head, and, on certain feast days, silver shoes put on its feet to protect them from pilgrims' kisses.

Of course, the statue has its legend. It was the work of Nicodemus, the Pharisee who 'came to Jesus by night' (John 3:1) to be taught by him, and who later assisted at his burial. Nicodemus was held to be a sculptor as St Luke had been a painter. Having seen Christ on the Cross, he tried to make a statue that would preserve the image for future generations, but the task was beyond human capacity. Waking up one day exhausted beside his unfinished crucifix, he found that an angel had completed the work. The statue was widely venerated, but when the Iconoclasts in the East threatened to destroy it, it set out for the safer shores of Italy, alone, in a boat without crew, pilot or other passengers. At last, in 742, it put in on the Tuscan coast. Once ashore, the statue was taken at once, in a chariot drawn by white oxen, to the cathedral city of Lucca.

What was most striking about the Volto Santo is not his dark colouring, Christ's radiant face having been marked by the sufferings caused by 'our foul, black, shameful deeds', as the mystic Julian of Norwich understood. The odd thing about this statue is that it shows Christ on the Cross wearing not just the loincloth familiar in Western Europe, but an ankle-length, long-sleeved tunic tied at the waist. And this, combined with the severe, crudely carved and painted features and the protuberant open eyes, gave him an air of alien majesty, an incontrovertible power which strongly affected those who saw the sculpture.

This alternative regal 'True Likeness' could hardly have been more different in aspect than the pitiful Veronica, and the divergent emotions they aroused in spectators were spelled out around 1390, by the theologian Matthew of Janov:

> *Nor is it without a special reason that only two portraits of Christ are famous in the church, one in Rome by the name of the Veronica, which has a gentle and friendly appearance … and one in Lucca … the Volto Santo, the face of which is terrible to behold, a commanding, majestic image. From this I conclude that the Lord Jesus, who will come a second time into the world and show himself to all, has left behind an image of his two manifestations.*
>
> *I can bear witness to this myself. Whenever I have seen this image, a kind of copy of the image, on a great flag in Lucca that was repeatedly raised in the air, I have always been terrified, my hair stood on end, because I thought of the coming of Christ to sit in judgment.*
>
> *Thus the names of the images were apt, for the* facies *in Rome reminds us of the face that is mild and full of mercy, while the* vultus [countenance] *in Lucca hints at the* furor *that is delineated terribly in the face. Thus the images match Christian doctrine, in that one recalls the gracious mercy and the other the rigorous justice of God.*

As early as the eleventh century, William Rufus, King of England, swore by the Volto Santo; by the late twelfth century, the era of the great pilgrimages, the fame of the terrible Christ of Lucca was assured throughout Europe. Chapels were dedicated to the statue's painted image, and even to exact copies in wood, made, we may presume, by artists who looked closely at the original. One such wooden sculpture is still venerated in Amiens Cathedral, where it is the subject of a local legend: this Christ was said to have bowed one day when the relics of St Honoré were carried by. Even copies can perform miracles, and this one is recorded in stone on the south portal of the cathedral.

31 Giuseppe Enrie, photographic negative, 1931, detail of the Turin Shroud showing Christ's face

was circumspect: the cloth, whether painted or not, deserved veneration as an image of the shroud of Christ.

In 1453 the shroud came into the possession of the Dukes of Savoy and was housed in a chapel in their capital at Chambéry, where in 1516 and again in 1532 it was damaged by fire, so that patches and a backing cloth had to be sewn on by Franciscan nuns. Promoted by the dukes, however, the shroud continued to rise in status and prestige. Pope Sixtus IV spoke of it as 'coloured with the blood of Christ'; Pope Julius II instituted a feast day of the Holy Shroud.

After the energetic Duke Emanuele Filiberto moved his capital to Turin in 1563, he naturally transferred the family's precious relic there, intending to erect a new church for its cult. In the event the shroud came to rest in 1694 in a sumptuous, geometrically complex black and gold chapel, itself the size of an ordinary church, appended to the east end of Turin Cathedral by Guarino Guarini.

On special occasions, such as Savoy family weddings, Savoy military victories or the birth of Savoy heirs, the cloth was taken out of its reliquary, unrolled, and – held by ecclesiastical dignitaries – displayed to crowds on the steps of the cathedral or on a vast outdoor stage constructed in front of the Ducal Palace. Engravings record every one of these displays, and each shows an image of the body of Christ as it might have been imprinted on a fourteen-foot-long sheet, laid on the ground underneath his body and then folded back until it covered his head: there is therefore both a frontal view of face and body, and a back view. These prints, and paintings commissioned by the shroud's owners, certainly conditioned what viewers thought they could see in the faint stains on the charred and patched cloth itself.

In 1861 Victor Emmanuel II, Duke of Savoy and – as he then was – King of Sardinia, became the monarch of a united Kingdom of Italy. The shroud remained the private property of the crown, but it was now also brought out and displayed on national occasions. At a display in 1898 King Umberto I was reluctantly persuaded to allow the shroud to be photographed. What was faint on the cloth emerged with greater clarity on the photographic negative. This was shown, back-lit in a darkened room, to members of the court and princes of the church. An aristocratic journalist broke the news to the public: 'The picture makes an indelible impression … the long and thin face of Our Lord, the tortured body and the long thin hands are evident. They are revealed to us after centuries, nobody having seen them since the Ascension into Heaven … I do not want to delay a minute in giving this news.'

These early photographs were superseded by ones taken in 1931 when the shroud was exhibited to celebrate the marriage of Crown Prince Umberto. And it

of those around me, and I was deeply moved. Whatever it may be in substance, this object draws many to a contemplation of Christ.

A weeping woman in the crowd said to me afterwards: 'I have seen my God.'

'If an image has an effect,' wrote Matthew of Janov in the fourteenth century, 'it is not because of the hand of the artist but because of the pious disposition of the beholder.'

The Turin Shroud has not been influential on Western art, because it was widely accepted as a True Likeness too late to affect the greatest inventors of Christian imagery. Indeed, those who believe in the shroud's authenticity do so largely *because* the image imprinted on it, when reproduced photographically, seems to resemble the likeness of Christ known to us through the Veronica and promulgated by famous artists of the past.

After the Veronica, perhaps no likeness of Christ has been given greater or wider currency than Leonardo da Vinci's *Last Supper* painted in the refectory of the Dominican convent in Milan [PLATE 32].

Leonardo had offered his services to Ludovico Sforza, Duke of Milan, as a civil engineer, a designer of lethal machines of war, of amusing mechanical toys, above all as a sculptor who could construct an equestrian statue commemorating the duke's father – and, almost incidentally – as a painter. (The letter from Leonardo enumerating these many skills may be a forgery, but its burden must, in essence, be true.) The Duke put Leonardo to work on the mighty Sforza Horse, as it was called, but he also commissioned him to paint a mural for the Dominican friars under his patronage. Their church was Santa Maria delle Grazie, which Ludovico conceived as a Sforza mausoleum; several of the family's tombs were already there.

The tradition of painting the Last Supper on the end walls of conventual refectories was already well established in Florence. As early as the mid-fourteenth century, Taddeo Gaddi had represented the scene for the Franciscans at Santa Croce – and he had made Christ and the disciples seem alive, sharing, as it were assisting in the friars' every meal.

Leonardo brought this Florentine convention to Milan. In 1498, after four years' work, he completed the great mural. Since then it has been copied and reproduced so many times that we feel we have known it for ever. Most of us – from whichever Christian tradition we may come, or none – if we think of the Last Supper, we think of this.

Fifty years after it was made, the painting was already described as half-ruined, and it has subsequently been much damaged – by damp, and worse – and often restored. Yet when the latest restoration was unveiled in 1999, all hell broke

32 LEONARDO DA VINCI *The Last Supper, c. 1495–8*

33 WILLIAM DYCE *The Man of Sorrows*, 1860

34 JEAN BÉRAUD *Christ in the House of the Pharisee*, 1891

Part of the poignancy of this story derives from the fact that the penitent woman's anointing of Christ's feet is meant to prefigure the anointing of his dead body for burial. That is why tradition conflated this nameless sinner with Mary Magdalene, who witnessed the Crucifixion, assisted at Christ's Entombment, came 'the first day of the week early' only to find the tomb empty, and was the first person to see him when he rose from the dead. Funereal though Béraud's colour scheme appears – dictated by the conventions of smart modern evening dress – it is difficult to recall this here.

It is indeed difficult to avoid asking oneself foolish questions such as, why is Christ wearing a nightgown to dine with these smug businessmen and politicians? How did the elegant *demi-mondaine* get into this house, so obviously well furnished with butlers and footmen, when the dinner was for men only? Is she the mistress of one or more of them? Less foolishly – who are we meant to identify with?

Béraud presumably meant his viewers to identify with the Pharisees – for no nineteenth-century male or respectable female could possibly identify with the sinful woman – but what is the moral they are meant to draw? And if we identify with none of them, what moral are *we* meant to take to heart?

What is this picture *for*, exactly? Béraud brings Christ into the contemporary world, and in part because of the True Likeness we recognize him. But the Gospel message of redemptive love and forgiveness is opaque. What works for the desolate figure of Christ alone in the wilderness, even a plainly Scottish wilderness, seems not to work here.

While there were nineteenth-century artists other than Dyce who could make it work – choosing, with better judgment than Béraud, symbolic scenes that brought Christ into the homes of the poor, or among those oppressed by tyranny – the device fell into disrepute. To paint stories from the earthly life of Christ, showing him as the familiar recognizable figure with long hair and beard, in biblical dress among people realistically depicted in modern fashions in a modern setting, became unthinkable for most serious artists. It was to be revived again in the mid-twentieth century: Stanley Spencer, for one, renewed archaic forms in a modern key – but it remains a rare and eccentric choice.

Twentieth-century figurative artists generally favour other ways of bringing us face to face with Christ. One of these – to find him in the suffering of our contemporaries, as was suggested by those close to the Turin Shroud – we will consider more fully in Chapter Eleven.

An alternative is to reject the traditional, familiar likeness, to accept that we cannot know what the historic Christ looked like and come to the problem fresh. But the weight of tradition is not so easily discarded.

35 (OPPOSITE) MARK WALLINGER *Ecce Homo*, 1999

Mark Wallinger's *Ecce Homo* was installed in July 1999 on a plinth in the north-west corner of Trafalgar Square [PLATE 35], across the street from the National Gallery. The plinth, nearly fifteen feet high on the street side and twenty-four feet high when viewed from the sunken square, was originally intended for William IV, who died without leaving funds for the provision of his statue; it has been empty since the square was opened in 1843. The other three plinths bear over-life-size statues of George IV and two Victorian military heroes of the British Raj, Sir Henry Havelock and General Sir Charles James Napier. In the centre of the square, of course, Nelson's giant effigy stares from his column with his one seeing eye.

Wallinger's statue is the first of three new works to be displayed on the plinth for a brief period. It was chosen to be shown over the turn of the millennium, to mark – whatever the historical fact, and however we compute it – the two thousandth anniversary of the birth of Christ.

Ecce Homo, Latin for 'Behold the man', are words spoken by Pontius Pilate after the crowd votes to free Barabbas the robber:

> *Then Pilate therefore took Jesus, and scourged him.*
> *And the soldiers platted a crown of thorns, and put it on his head, and they put on him a purple robe.*
> *And said, Hail, King of the Jews! and they smote him with their hands.*
> *Pilate therefore went forth again, and saith unto them, Behold, I bring him forth to you, that ye may know that I find no fault in him.*
> *Then came Jesus forth, wearing the crown of thorns, and the purple robe. And Pilate saith unto them, Behold the man!*
> *When the chief priests therefore and officers saw him, they cried out, saying, Crucify him, crucify him.*
> JOHN 19:1–6

The title is applied to images of Christ shown to the people, and it implies that the viewer is one of those that see and condemn him: Crucify him, crucify him! As a theme in art it was hardly known before the fifteenth century, and it became popular all over Europe only later. Artists treated it in two quite distinct ways: as a devotional image where Christ appears alone, or as a narrative depiction of the whole scene – but the message is always the same: Behold the man!

Wallinger's *Ecce Homo* is not a conventional sculpture: it is a cast, in synthetic resin mixed with white marble dust, of the whole body of a clean-shaven

former art student employed in the casting workshop. That makes the figure, by definition, life-size. The young man wore a rubber bathing cap during the casting, so this Christ seems to be bald as well as beardless. He had to keep his eyes shut. According to one journalist, 'the sculpture's enigmatic ... expression is ... a matter of the model's stoical endurance during the lengthy casting process'. The figure's hands are tied behind its back. There is no mock-royal robe, only a loincloth cast from a towel around the naked body. A crown of gold-plated barbed wire encircles the head.

Standing at the very edge of the plinth, facing across Trafalgar Square, the statue is dwarfed by the triumphal overscale sculptures, monarchs and heroes of empire who are its neighbours. Cars and buses judder by; ice cream and hot dogs are sold, pigeons fed; and the passers-by and tourists who notice the small, frail-looking figure above them can hardly believe their eyes.

This is a figure of the historic Christ – not a Christ perceived in the victim of some contemporary disaster – but it is at the same time the figure of an anonymous, an ordinary young man. His face is not a True Likeness; it owes nothing to the Mandylion, the Veronica or to Leonardo. Yet if Christ were a prisoner led to his execution today, might he not look like this? Behold the man!

Reactions have been mixed. 'Profoundly moving,' said the Bishop of London, and the Catholic Bishop of Westminster was also moved by 'his very human scale among all this grandeur'. Two young students decided it was 'the best thing that has happened in art'.

Others were less sure. 'If that's Jesus Christ, it's a bloody miracle,' a man is reported to have said (they seem to have interviewed no women). 'You couldn't put your faith in someone like that, he's as weak as a kitten.' 'You can't have a Christ figure like this,' said another. 'Where is his robe? Where is his beard? Where is his cross?' An ice cream seller pointed out, 'He doesn't have long hair.'

We all still know what Christ looks like.

Mark Wallinger is quoted in the press release issued when the statue was installed: 'Whether or not we regard Jesus as a deity, he was at the very least a political leader of an oppressed people. The sculpture alludes to the recent historical past and its sad record of religious and racial intolerance.'

There is a Christ for every age.

But the *Ecce Homo* in Trafalgar Square reminds us also that in every age we, like the crowd that stood in the square in Jerusalem, must make our choice between Barabbas and Christ.

36 FRANCISCO DE ZURBARÁN *Christ on the Cross, c.* 1632–4

Wilfred Owen's famous and subversive First World War poem, *At a Calvary near the Ancre*, was inspired by one of the many crucifixes that still stand at crossroads in Belgium and northern France. They were particularly striking to the British troops, since nothing like them could be seen on the rural roads they knew, back home in a Protestant country. But there was another, grimmer, reason why the image of crucifixion made such an impact on British soldiers. The penalty for petty infractions by Other Ranks was 'Field Punishment No.1'. This consisted of being tied spread-eagled to some immobilized object, like a large spoked wheel. 'Wouldn't the army do well,' it was asked, 'to avoid punishments which remind men of the Crucifixion?' The soldier's humiliation was disconcertingly close to Christ's.

The crucifix in Owen's poem has been mutilated by artillery fire. Christ's frightened disciples have forsaken him, but soldiers bear the Cross, suffer and die in the trenches and on the battlefields. The priests commissioned as officers to minister to them escape with flesh wounds – superficial wounds that are also the deeper sign of a pact with the devil: supporting the war against Germany and, with the established Church, with the State teaching and urging hatred. One of Owen's letters, written on 2 May 1917, makes even clearer the message of the last two stanzas:

> *Already I have comprehended a light which will never filter into the dogma of any national church: namely, that one of Christ's essential commands was, Passivity at any price! Suffer dishonour and disgrace, but never resort to arms. Be bullied, be outraged, be killed; but do not kill …*
>
> *Christ is literally in no man's land. There men often hear his voice. Greater love hath no man than this, that a man lay down his life – for a friend.*
>
> *Is it spoken in English only and French? I do not believe so.*

The bare crosses which mark the graves of the dead soldiers fallen in Flanders fields were set there as emblems of faith in Christ's promise in the Resurrection of the flesh. Yet by most people, believers and unbelievers, they are now more often construed as reminders of political injustice and ineptitude. Their ordered ranks still speak to us of suffering endured and of the futile slaughter of both sides. The dead of France and Germany alike are marked by a simple cross, eloquent of desolation and loss, of what Siegfried Sassoon called

> *The unreturning army that was youth;*
> *The legions who have suffered and are dust.*

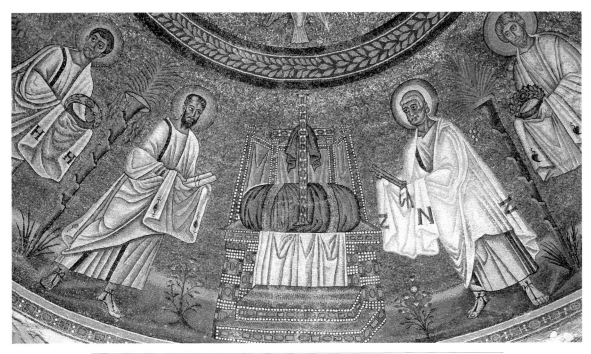

37 Detail of PLATE 25, showing *The Empty Throne*, Arian Baptistery, Ravenna, 493–526

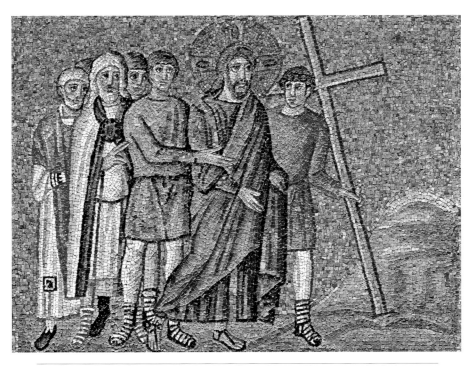

38 *The Road to Calvary*, mosaic, Sant'Apollinare Nuovo, Ravenna, early sixth century

39 *Scenes from Christ's Passion*, ivory plaques, 420–30

suffering which we behold. And by 1918 the crucified Christ had become an image of all men's suffering, of selfless love and grief. How did this revolution in theology come about?

The monks who in the cloister redirected devotion from Adoration to Nativity, from the Child King to the Child born to die, proposed a whole new vision of man's relationship to God. God the Father is all-powerful, yet wills his only Son to atone for our sins through his suffering. Crudely put, we are saved less by the power of God than by the weakness of Christ. It is Christ's willingness to be weak for our sake and his acceptance of suffering that save us. When the monks' disciple, Brother Francis of Assisi, decided to follow in Christ's footsteps, he allied himself with society's weak and despised. And when Francis's followers spoke of the saint's resemblance to Christ, they cited his humility, his child-like innocence, his physical privations and sufferings, and the stigmata – the five wounds of Christ – imprinted on his body and discovered after his early death.

Once the notion of salvation had been refocused in this way from the intervention of God the Father to the physical suffering of the Son, the art of Western Christendom changed dramatically. As we saw in the imagery of Christ's birth and infancy, it now often depicted the horror of the Incarnation as much as its miraculous aspect. Yet along with the horror it set out also to evoke love, that boundless love the Incarnation signifies and requires: God's love and our own.

A newly reunited diptych – two panels hinged to open and close like a book – now at the National Gallery in London makes the point [PLATE 40]. It was painted a little before 1300 by an unknown master probably working in Umbria – St Francis's native region, where he found his earliest and most fervent disciples. A small diptych like this could function somewhat like an altar, a book, or a pair of photographs framed together: as the portable focus of private worship, perhaps while travelling; or as an object from which to draw information and food for thought; to remind us of those we love.

This diptych is the earliest known example of a type that, under Franciscan influence, was to become extremely popular. The left-hand panel shows the *Virgin and Child*. The image of Christ on the right represents *The Man of Sorrows*. While angels mourn, we see the dead Christ in front of the Cross, his head inclined towards the Mother and Child. When the diptych was closed, or opened part-way to stand on a supporting surface, the two images faced each other.

I have learnt from John Drury – priest, scholar and inspired viewer of Christian art – to ask, what *is* the hinge between the two panels of a diptych? One answer, here, must surely be the Incarnation. These are the two forms in which God became man. The loving and beloved child is the mirror image of the

wounded man; the man's tortured body reflects the child's tenderness. As the mother embraces the child, she foresees her embrace of his dead body. Her joy in the one is exactly matched by the sorrow evoked by the other, and the emotions are not contradictory: who does not love cannot grieve, and it was for love that this man suffered. The two panels are like the alpha and omega of the Greek alphabet, the first and last letters between which early Christians inscribed the monogram of Christ (see p. 68; PLATE 19).

The right-hand panel does not show Jesus Christ on the Cross: its image is that of the famous vision of the dead Christ that appeared to St Gregory on the altar as he was celebrating Mass. St Francis, in a different vision, saw the flesh-and-blood infant Christ in the Host of the Eucharist; on another occasion, a woman in the congregation fainted when he took communion, for he seemed to be eating a live baby. The diptych does not record some past moment of history, any more than framed studio photographs of our loved ones do. The artist is showing us, through the lens of the new theology, the Christ who is always among us, in need of our protection as a baby, dying for us as a man. It is, in every sense, a vision of God.

Atonement means to pay a debt. In the new theology that Francis inherited, and taught to the whole of Europe, our debt of sin is paid through Christ's sufferings, and as the number and scale of our wrongdoings grow, so, necessarily, do his sufferings.

The artist now has the task of showing the direct link between our sin and Christ's pain, reminding us that if Christ is on the Cross, it is our fault. How can so complex an idea be made visible?

A life-size crucifix now hangs above the altar in a chapel in Seville Cathedral [PLATE 43]. Carved by Juan Martínez Montañés, an older contemporary of Zurbarán, and possibly Spain's greatest sculptor, it is a delicate conflation of Flemish realism with Italianate idealization, entirely characteristic of the artist. Christ's slender body remains beautiful in agony; the loincloth, tied in a looped knot inherited from Gothic art, gathers gracefully about the figure. Velázquez's teacher, the Sevillian painter Francisco Pacheco, boasted in his treatise *El Arte de la Pintura*, published in 1649, that he painted the sculpture in matt colours – which he claimed to have been the first to use – to make it seem more natural, warming the pallor of the skin, marked with trickles of blood.

Christ's head, crowned with thorns, falls to one side, and from the entrance to the chapel he appears to be dead. Yet he is not; the sculptor precisely followed his patron's instructions, and we, luckily, still have the contract recording them.

The crucifix, known as the *Christ of Clemency*, was commissioned on 5 April 1603, by Mateo Vázquez de Leca, Archdeacon of Carmona Cathedral. In spite of being in holy orders, he had led a dissolute life until his sudden conversion on the feast of Corpus Christi 1602. At dusk on that day, a woman wrapped in a cloak is said to have approached him and beckoned him to follow her. Hoping for a conquest, he asked her to uncover her face. She loosened her cloak and revealed – a skeleton.

Vázquez de Leca stipulated that the crucified Christ was

> *to be alive, before He had died, with the head inclined towards the right side, looking to any person who might be praying at the foot of the crucifix, as if Christ Himself were speaking to him and reproaching him because what He is suffering is for the person who is praying; and therefore the eyes and the face must have a rather severe expression, and the eyes must be completely open.*

Montañés was inspired by the commission. He says in the contract: 'I have a great desire to complete and make a work like this to remain in Spain and not be taken to the Indies [South America] nor to any other country, to the renown of the master who made it for the glory of God.' The crucifix was placed in Vázquez de Leca's private chapel. We can easily imagine him praying at its feet, looking up at Christ's 'rather severe expression', at the eyes whose dark pupils Pacheco picked out with highlights. Standing there today, we do indeed seem to see Christ looking down and reproaching us. We can almost hear the Reproaches still used every Good Friday in the Roman liturgy, in which Christ recounts God's blessings on his people, and how they have repaid good with evil:

> *O my people,*
> *What have I done unto thee?*
> *And wherein have I wearied thee?*
> *Answer me ...*
>
> *I crowned you with a royal sceptre,*
> *Yet you plaited a crown of thorns ...*
>
> *I gave you an arm of strength,*
> *Yet you dealt me a cross of shame ...*

The *Christ of Clemency* speaks powerfully, even today. The contract makes it plain that the sculptor considered it as a work of both art and devotion. And for the patron who commissioned it, its value as a work of art resided above all in its ability to communicate directly with him, and to bring him in to dialogue with Christ himself.

Montañés's Christ reminds us gently of our role in his pain. But there were tougher, much tougher, ways of making the same point, and they were favoured especially by artists in Northern Europe. Less influenced than Italians by ancient Roman sculpture that equated divinity with bodily beauty, Northern artists had no qualms in picturing a Christ disfigured by suffering, the 'man of sorrows', that 'righteous servant' who 'hath no form nor comeliness' of Isaiah's prophecy (Isaiah 53).

Between 1510 and 1516 the enigmatic German master Mathis, now called Grünewald, painted a large and complex folding altarpiece for the Antonine canons of Isenheim, a small locality in Alsace. The altarpiece, saved from destruction but dismembered when religious orders were suppressed during the French Revolution, is now in the Musée des Beaux-Arts at Colmar, and one of its panels shows perhaps the most terrifying Crucifixion in Western art [PLATE 41].

Other than his paintings, we have no contemporary record of Master Mathis, but we know a great deal about the Antonines who commissioned him. The Order's patron saint was Antony Abbot, a legendary fourth-century hermit who retired in penance to the Egyptian desert. There, like any holy hermit, he was assailed by lurid temptations – but also by demons who, taking the shape of wild animals, painfully clawed and tore his flesh. By association, the relics of St Antony, brought around 1083 from Constantinople to France, were thought to have effected miracles in curing diseases that attacked the skin, and it was to care for the victims of these that first a confraternity of laymen, then, in 1202, the religious Order of the Antonines, were constituted.

The Antonines sheltered pilgrims; they nursed lepers and victims of the plague, but above all they specialized in the treatment of St Antony's Fire. This was the name given both to erysipelas, a streptococcal inflammation of the skin, and to the more dreadful and often fatal ergotism, caused – as we now know – by a fungus that attacks rye, the staple cereal of Northern Europe. In times of famine, mouldy rye would be milled into flour along with the healthy grain, contaminating the bread eaten by an already weakened population. The result was recurring epidemics, in which the skin of those affected itched and burned, then turned black and gangrenous until limbs were literally detached from the body. All this was naturally accompanied by excruciating pain, and frequently by hallucinations.

40 (ABOVE AND OPPOSITE) Unknown Umbrian Master *The Virgin and Child*
and *The Man of Sorrows, c.* 1260

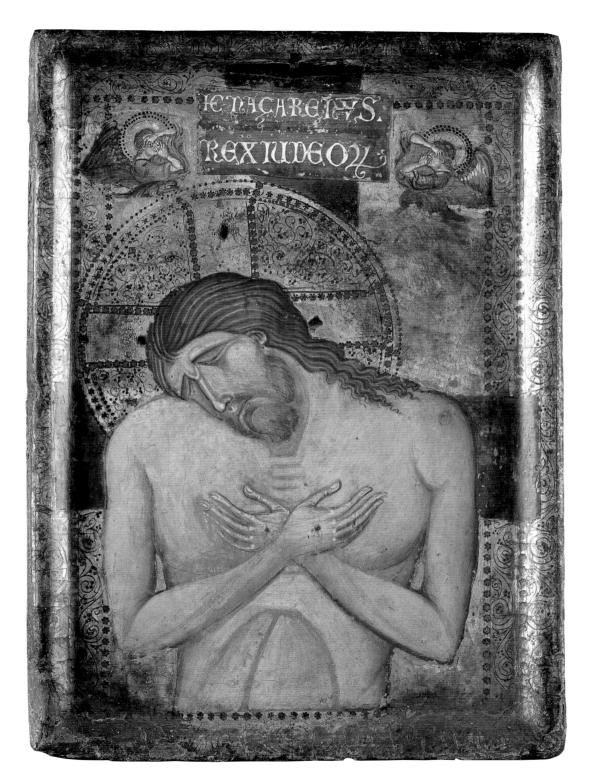

Scala Santa in the Lateran in Rome, so that here too we can exactly follow Christ's painful footsteps.

One of the most vivid chapels here is that of the *Ecce Homo* [PLATE 42]. Above the grille through which we look into the courtyard of the palace an inscription cites Isaiah's haunting passage on the Man of Sorrows, followed by a verse from St John's Gospel (19:5): 'Then came Jesus forth, wearing the crown of thorns, and the purple robe. And Pilate saith unto them: Behold the man!' Nothing is left to imagination. We see precisely what is going on and how everybody is reacting. It is as though we were not just watching a newsreel, but taking part in it. Pilate has a tough political decision to make. If he now sets Christ free, he risks provoking a riot. But to play it safe means condemning to death a man in whom he can find no fault. Like the deft politician he is, he chooses to leave it to the people.

And it is we, standing with the crowd here in the courtyard of Roman head-quarters in Jerusalem, who must now decide.

The great lesson the Franciscans hoped to teach at Varallo is that this is a drama to which we cannot remain indifferent. Following in the footsteps of Christ does not let us off the hook; feeling compassion is not enough. We can never only identify with the innocent – we must also see through the eyes of the guilty. For we, like them, have rejected him.

Placed on the boundary between Latin and German Europe, Varallo is a powerful mix of different aesthetic traditions: the engaging realism of the North here has been put to the service of the emotional rhetoric of Italian art. Working in two registers at once, this can, at its best, deliver a knock-out blow. We find a very similar mixture in Spain, where commercial and political ties to both the Low Countries and Italy produced work which, in its impact, can often be compared with Varallo. One of the things the Spaniards inherited from Northern artists was a taste for gilded or polychromed wooden sculpture, and religious statues colour-fully painted to look as life-like as possible are still made in Spain to this day. These statues are uniquely suited to the forms of piety promoted by the Franciscans, and the Franciscans were extremely active in Spain and in its empire in the New World.

The great sixteenth-century Spanish mystic and religious reformer, Teresa of Avila, influenced by the writings of a Sevillian Franciscan, Fray Bernardino de Laredo, credits her conversion, and her gift of focused prayer, to just such life-like images. It is precisely the kind of response which the founder of Varallo hoped to achieve in his Sacro Monte, and the account she gives in her *Life* (Chapter IX) is worth quoting to show how powerfully these works of art could change lives.

42 (OPPOSITE) MORAZZONE and GIOVANNI D'ENRICO *Ecce Homo*, Chapel 33, Sacro Monte, 1603–16

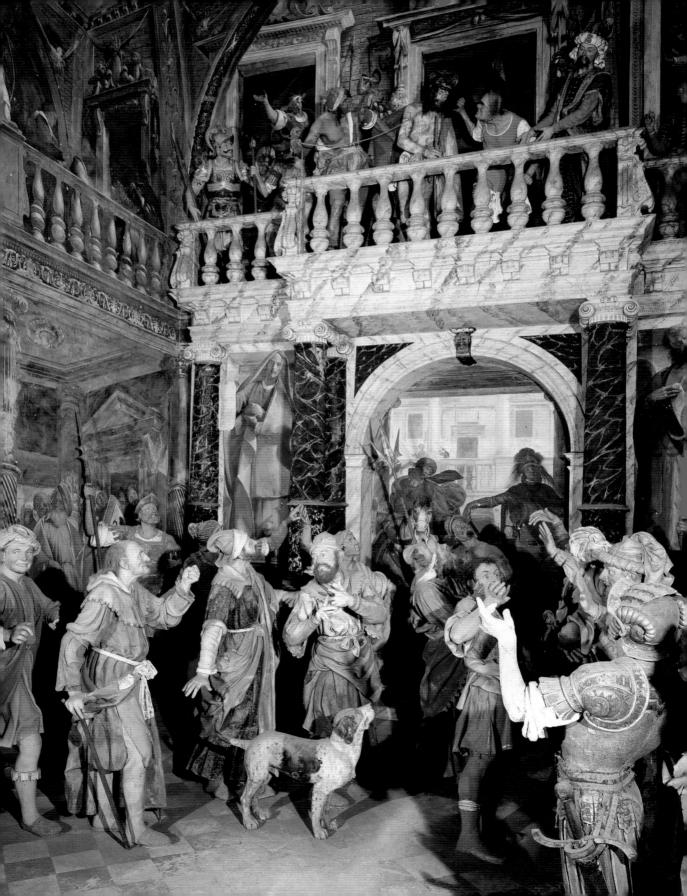

representation and the thing it represents can be spiritually fruitful, even if dangerous. And although voices within the Spanish Church were raised against the Holy Week spectacles, they remained the prime vehicle for popular devotion. Even austere churchmen preferred the sculpted figures to the live actors who had earlier moved audiences in Passion plays:

> *If there is anything in Spain that offends pious foreigners and natives in this celebration, it is seeing that vile and infamous men, accustomed to enacting vulgar and offensive things all their lives, represent such lofty and ineffable mysteries, and that the woman that represents the vulgarities of Venus, in theatrical productions as in her own life, represents the purity of the Sovereign Virgin in such a solemn and divine act.*

It should not, therefore, surprise us that Martínez Montañés, the sculptor of the refined *Christ of Clemency* [PLATE 43], should have accepted a commission from the penitential Confraternity of the Martyrdoms and Blood of Our Lord Jesus Christ, founded in Seville in 1531 in the Convent of Our Lady of Mercies, for a processional statue of Christ carrying the Cross: *Jesús de la Pasión* [PLATE 44]. The confraternity, relocated and merged with another, still exists, and the statue is normally venerated in the chapel of the Sacrament in the grand parish church of El Salvador, the Divine Saviour. As it was designed to be carried through the streets, it is both coarser and more expressive than the *Christ of Clemency*, the boldness of the carving and the polychromy make the face – with lowered eyes, open mouth and blood running down from the crown of thorns – and the veined hands and feet, clearly legible from a distance. The body is always hidden under a velvet robe, but we know from photographs taken during restoration that it is more like a mannequin than a 'pure' sculpture. The arms are hinged at the shoulders and elbows, so that the angle of the cross can be adjusted.

Behind the altar of its chapel, in front of a dazzling silver reredos, with elaborate gold metal rays issuing from behind its head, and a spotless lace altar cloth before it, this suffering Christ is a powerful yet incongruous figure – an embodiment of pain in spotless, almost stifling opulence.

But during Holy Week the *Jesús de la Pasión* comes into his own – and unto his own – as he has for over three hundred years, and carries his Cross through the streets of Seville. The faithful here do not have to go on pilgrimage – to Palestine, to Rome or to Varallo – they can follow the footsteps of Christ as they come out of their own front doors. They can look up to him from the pavement, or watch him from their balconies. They can see him appearing from a distance,

43 (OPPOSITE) JUAN MARTÍNEZ MONTAÑÉS *Christ of Clemency*, Cathedral, Seville, 1603

communal dormitories but in individual cells, which they were also expected to use for solitary study and meditation. So the decoration of the novices' cells could be expected to provide the clearest example of how to become a good Dominican: and each of these cells contains an image of Dominic at the foot of the Cross, like the one that greets us in the cloister.

At first sight, all appear to be identical. Only when we look more closely do we notice that in each one the saint is shown in a slightly different pose. In a treatise intended for use by Dominicans, an eyewitness of Dominic's devotions recounts the founder's nine different modes of prayer. Eight were silent, so that only through his gestures was it possible to know what was in his mind. Fra Angelico's frescoes closely follow the painted illustrations in the manuscripts of this treatise – and both illustrations and frescoes are clearly based on a simple theory of imitation. Dominic's states of mind can more easily be evoked and re-created in the viewer if he can replicate the appropriate gestures.

These gestures reveal that the saint is engaged in different kinds of devotion: Cell 15 shows rapture in prayer, while Cell 18 depicts humble reverence, and Cell 19 meditative reading of a holy text. The stress on meditation, on *thinking* rather than *feeling* the Passion of Christ, is even more obvious in the clerics' cells, where the decoration is mostly based on biblical events that are major liturgical feasts of the Church.

The fresco of Cell 7 depicts the *Mocking of Christ* [PLATE 47]. But this is in no sense like a chapel at Varallo, a realistic rendering of the incident. Beneath a schematized selection of aspects of the event, we see Dominic, not looking at Christ in his humiliation, but meditating on a *written* account of the Mocking of Christ. This is an art at several removes from observed reality, a vision already distilled by analysis and long reflection. So Dominic does not witness the actual event, but systematically visualizes each separate moment, each cruel act, from the torturer's tipping his hat in mockery as he spits at Christ, to the buffet of one dis-embodied hand and the blow of another holding a wooden rod. The blindfolded Christ, enthroned in derision, is a real King and Judge; he is not shown in the purple robe of the Gospels but in the spotless white of an innocent victim. Like the blindfolded Christ, we apprehend the assaults individually, as disembodied incidents, unable to see or consider them all at once.

In the same thought-space as St Dominic, but on the opposite side of the picture, sits the Virgin Mary, patron of the Dominican Order. As her sorrowful pose makes clear, she – unlike the friar – apprehends her martyred son's pain directly, without the intervention of a text. As the preachers think, Mary feels.

In these cells built for silent study and prayer, the ultimate purpose of the

46 (OPPOSITE) FRA ANGELICO *St Dominic at the Foot of the Cross*, c. 1441–3, in the cloister of San Marco, Florence

anguish, not a Christ dead in the certainty of victory. The figure of the centurion Longinus has been nearly effaced, and his place in the drama taken by a man in a tall three-tiered hat, carrying a long baton of command and mounted on a horse.

The exotic rider derives from a famous fifteenth-century medal designed by Pisanello and cast for the Duke of Mantua, which Rembrandt, an insatiable collector himself, probably owned. Here, the horseman must represent secular authority: 'And the people stood beholding. And the rulers also with them derided him' [Luke 23:35]. But, in a return to the tradition of Passion plays, he may be Pontius Pilate himself, shown as the military commander (whose part was after all a relatively humble one) of the occupying Roman forces. Both the centurion and Pilate were guilty of Christ's death. The centurion repented and bore witness. Pilate, on the other hand, though he believed Christ to be entirely innocent, had connived through weakness at great injustice, and condemned him to death. If he is Pilate, the mounted figure on the left can stand for the greatest human weakness: we could do something to prevent injustice and suffering, but choose not to.

While Rembrandt's subject in the earlier version of the *Three Crosses* was the redemptive power of the Crucifixion, symbolized by light, his theme now is, literally, darker: persistent human sinfulness, which prolongs Christ's suffering and dooms us to despair. One figure on the right can be made out, standing in the gloom, gazing at Jesus. It must be St John, and the etching could be a glimpse of the bleakest verse in his Gospel: 'And this is the condemnation, that light is come into the world, and men loved darkness rather than light, because their deeds were evil' (John 3:19–20).

We do not know whether Rembrandt's changes to the *Three Crosses* mirrored changes in his own state of mind in the troubled years towards the end of his life; the artist whose face is known to us more intimately than any other's kept his own counsel, and left no evidence beyond the etchings themselves.

We know a great deal, on the other hand, about what Michelangelo felt when, at the end of his life, he sculpted his two last great versions of the *Pietà*.

The Italian word *pietà* means both piety and pity; devotion and mercy. It is used in Italian art to designate images of the dead Christ lamented by his mother, alone or with others. But there are many different moments between the Crucifixion and the Entombment, and the theme can be richly inflected.

Michelangelo first addressed it when, as a young man of twenty-two, he was commissioned by a French cardinal, Jean Villier de la Grolaie, to sculpt a *Pietà* for his funerary chapel in St Peter's in the Vatican [PLATE 51]. Jacopo Galli, the go-between who organized the commission, asserted that it would be 'the most beautiful marble statue in Rome, and no living artist could better it'. Few

51 (OPPOSITE) MICHELANGELO *Pietà*, 1497–1500

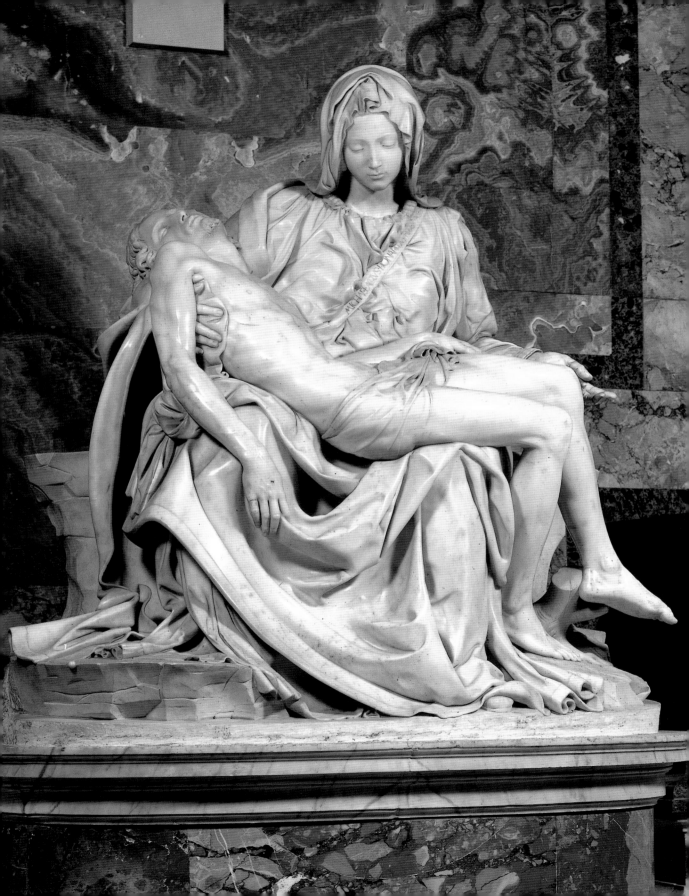

people today would disagree. What Leonardo's *Last Supper* is to the imagery of Christ's life, Michelangelo's Vatican *Pietà* is to his death. Innumerable reproductions have made this effigy familiar: and this is how most people, Catholics, Protestants and unbelievers, now imagine the Virgin Mary bidding farewell to her son before consigning him to the tomb.

Yet Michelangelo was doing something new, for this is the earliest Italian sculpture of this subject. Italian artists had been representing the Lamentation over the dead Christ since the thirteenth century, but always in scenes where Mary is joined by the disciple St John and the holy women. The independent effigy of the lamenting Virgin with her son was a German invention, intentionally recalling images of the Mother and Child. It spread as a focus of devotion, and as a funerary image, from Germany to the Netherlands, England, Spain and France, and it must have been the French Cardinal Villier who specified the two-figure group when he ordered a life-size marble version for his own tomb.

Mary sits on a rock, her right foot slightly raised, with the limp body of Christ on her lap. Vasari, the sixteenth-century painter, architect and art historian – and Michelangelo's fervent admirer – writes of it in his *Life of Michelangelo*:

> *No portrayal of a corpse can be more realistic, yet the limbs have a rare beauty, and the muscles, veins and nerves stand out to perfection from the bone-structure. The face bears an expression of infinite tenderness, and all the joints, especially those which link the arms and legs to the body, have a wonderful harmony. So superb is the tracery of veins beneath the skin that it is a source of never-ending wonder how an artist could achieve such divine beauty.*

The sculpture is not, however, an image of the dead Christ but of Mother and Son, together, undivided in the beauty of youthful death, and scholars have rightly, I believe, associated it with verses in Dante's *Divine Comedy* that purport to be a prayer by St Bernard addressed to the Virgin. The Italian is so beautiful that I will cite it in the original as well as in English translation:

> *Vergine madre, figlia del tuo figlio,*
> *Umile ed alta più che creatura,*
> *Termine fisso d'eterno consiglio.*
> *Tu sei colui che l'umana natura*
> *Nobilitasti sì, che il suo fattore*
> *Non disdegnò di farsi sua fattura.*

Virgin mother, daughter of your son,
Lowly and exalted more than any creature,
Fixed purpose of the eternal counsel,
You are she who so ennobled human nature
That its maker
Did not disdain to make himself of its making.

The Florentine Michelangelo was an ardent reader of Dante, the great Florentine poet, and knew long stretches of his *Divine Comedy* by heart; there is no reason to doubt that he had this celebrated passage in mind. It would explain what has seemed puzzling to many viewers: why the Virgin in the Vatican *Pietà* appears so young, and so beautiful at this moment of atrocious grief. When asked, Michelangelo, known for his gruff and ironic Florentine wit, is said to have replied: 'She has stayed young because she has stayed pure [i.e. a virgin].' But the youthful sculptor and student of antique statuary, who believed with the Neoplatonist philosophers of the Medici court that physical beauty is an emblem of the beauty of the soul, is more likely to have been inspired by Dante's theology. Michelangelo's Virgin is young and beautiful because his Christ must be young and beautiful – like a sculpted pagan divinity, say, the sun god Apollo; and Dante's verses stress the natural, familial likeness between Mary and her Son. The Vatican *Pietà*, although intended to be placed above an altar, where Christ's death will be regularly re-enacted, is a particular meditation on the Incarnation, when the beauty of God was made manifest on earth.

On the Virgin's sash the young prodigy proudly inscribed the words *Michel Angelus Buonarotus Florentinus faciebat*: 'Michelangelo Buonarroti, Florentine, made this'. It was to be the only time he signed his work.

Many decades later, when Michelangelo was in his seventies, obsessed with thoughts of mortality and sin, he returned to the theme of the dead Christ in a sculpture, this time made to stand on an altar above his own tomb. Exasperated with faults in the marble, and perhaps for other, more personal reasons, he left it unfinished and mutilated, with Christ's left leg broken off. Rescued from total destruction by friends of the sculptor, it is now in the museum of Florence Cathedral [PLATE 52].

The still moment of Lamentation is past. Michelangelo now shows us the more active Deposition or Entombment, and so he shifts the focus from the Virgin Mary, now a huddled figure on the right, to the body of Christ; from the mystery of the Incarnation to that of the Eucharist. For as Christ's gigantic body, broken in suffering and death, is lowered onto the altar, it becomes in every celebration

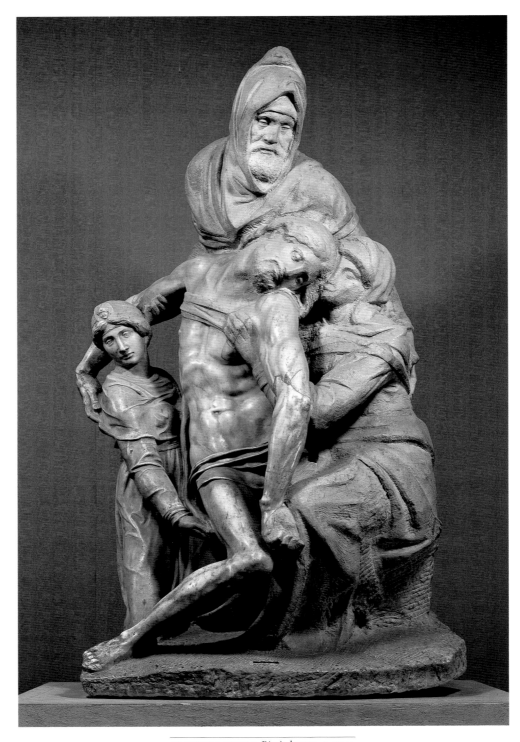

52 MICHELANGELO *Pietà*, begun *c.* 1545

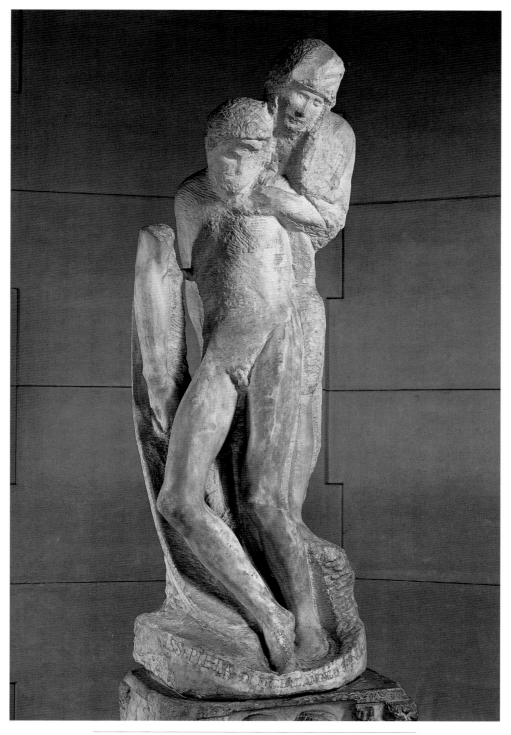

53 MICHELANGELO *Rondanini Pietà*, unfinished at artist's death, 1564

of the Mass, the 'bread of life' of his promise: 'If any man eat of this bread, he shall live for ever: and the bread that I will give is my flesh' (John 6:51).

On the left is one of the holy women, probably Mary Magdalene, attending the Virgin – a figure left unfinished by Michelangelo and later brought to chilly completion by another sculptor, Tiberio Calcagni. Behind and above, assisting the Virgin in supporting the dead Christ, is a tall hooded man with the distinctive broken nose and brooding face of Michelangelo himself. He could be Joseph of Arimathaea, the rich man who offered his own tomb for Christ's burial, but Michelangelo's pupil and biographer Condivi identifies him as Nicodemus, who provided a hundred pounds of myrrh and aloes to anoint the body of Jesus (John 19:39).

There are many reasons why Michelangelo may have wanted to identify himself with Nicodemus, the fearful Pharisee who in St John's Gospel comes to Jesus by night. In the conversation that St John records, one of the most extended dialogues in any of the Gospels, Jesus gives this one man an exalting vision of divine mercy. What might these words have meant to Michelangelo?

Verily, verily, I say unto thee, Except a man be born again, he cannot see the kingdom of God.

Nicodemus saith unto him, How can a man be born when he is old? Can he enter the second time into his mother's womb, and be born?

Jesus answered, Verily, verily, I say unto thee, Except a man be born of water and of the Spirit, he cannot enter into the kingdom of God.

That which is born of the flesh is flesh; and that which is born of the Spirit is spirit.

Marvel not that I say unto thee, Ye must be born again.

The wind bloweth where it listeth, and thou hearest the sound thereof, but canst not tell whence it cometh, and whither it goeth: so is every one that is born of the Spirit.

Nicodemus answered and said unto him, How can these things be?

Jesus answered and said unto him, Art thou a master of Israel, and knowest not these things?

Verily, verily, I say unto thee, We speak that we do know, and testify that we have seen; and ye receive not our witness.

If I have told you earthly things, and ye believe not, how shall ye believe, if I tell you of heavenly things?

And no man hath ascended up to heaven, but he that came down from heaven, even the Son of man which is in heaven.

And as Moses lifted up the serpent in the wilderness, even so must the Son of man be lifted up:

That whosoever believeth in him should not perish, but have eternal life.

For God so loved the world, that he gave his only begotten Son, that whosoever believeth in him should not perish, but have everlasting life.

For God sent not his Son into the world to condemn the world; but that the world through him might be saved.

JOHN 3:3–17

To the artist at this stage of his life, tormented by doubt and fear, Jesus's assurance that an old man like Nicodemus could be born again, and saved, must have spoken powerfully and consolingly.

But Nicodemus, as we saw in Chapter Six, was according to legend also the sculptor of the *Volto Santo* [PLATE 30], a True Likeness of Christ. And it is surely in both aspects of Nicodemus, as artist and as anguished believer who anointed Christ for burial, that Michelangelo here plays his part in the Passion and makes ready for the tomb the body of his Saviour.

We know something of Michelangelo's state of mind while he worked from Vasari's *Life*, where the author writes of himself in the third person:

Once Vasari was sent by [Pope] Julius III at the first hour of the night to Michelangelo's house to fetch a design, and he found Michelangelo working on the marble Pietà that he subsequently broke. Recognizing who it was by the knock, Michelangelo left his work and met him with a lamp in his hand.... Then Vasari's eye fell on the leg of the Christ on which Michelangelo was working and making some alterations, and he started to look closer. But to stop Vasari seeing it, Michelangelo let the lamp fall from his hand, and they were left in darkness. Then he called Urbino [Michelangelo's servant] to fetch a light, and meanwhile, coming from the enclosure where he had been working, he said, 'I am so old that death often tugs my cloak for me to go with him. One day my body will fall just like that lamp, and my light will be put out.'

By night, by lamplight, Michelangelo attacks the stone block to find in it figures bound together in love and sorrow, before Christ's body slides out of reach – hands wreathed about the great stone pyramid, comforting, reaching out, holding on, relinquishing.

In the crude urgent hatching of his claw chisels, in these unformed yet infinitely expressive faces, we sense the old sculptor hastening to assert his faith in the redeeming grace of his Saviour. For it is in front of this figure which he himself has created, that he intends masses to be said for his soul.

Yet, in the end, the recalcitrant marble defeats him, and he rejects the never-finished work, sets out to smash it utterly. Having, as a young man, sought God in the radiant nudity of pagan gods and polished marble, Michelangelo could not, even here, overcome the compulsion to interpret spiritual grace by physical means. This dead Christ is no longer the youthful Apollo of the Vatican Pietà – but it is nonetheless his perfectly muscled body, like that of an ancient athlete and warrior, that signals the immensity of his suffering, the pathos of his sacrifice.

Having abandoned the Florentine *Pietà*, Michelangelo did not, however, abandon the theme of the dead Christ. As Vasari tells us: 'It was now necessary for him to find another block of marble, so that he could continue using his chisel every day; so he found a far smaller block containing a *Pietà* already roughed out and of a very different arrangement.' This work was bequeathed by Michelangelo to a faithful servant and is now in the Castello Sforzesco, the city museum of Milan; it is known as the *Rondanini Pietà*, after a Roman collector who once owned it [PLATE 53]. We see it as it was on that Saturday in February 1564, when a visitor – Michelangelo's young protégé the painter Daniele da Volterra – found the eighty-nine-year-old sculptor standing all day working on the body of Christ. Five days later the old man was dead.

Three versions at least of this group are visible in the one sculpture, of which two were rejected and mutilated by Michelangelo himself. The polished legs of Christ, and his detached right forearm, belong to the first version, begun perhaps even before 1545, when he started work on the Florentine *Pietà*. But he must have abandoned this conception, and carving deeper into the stone that remained, he roughed out the forehead and hairline of another figure of Christ, above and to the right of the present figure, and the forehead and eyes of another Virgin Mary. These seem to belong to the early stages of a second version. That, in its turn, seems to have been rejected. And what was left of the marble block was worked for a third time, in pursuit of yet another vision of this moment of ultimate loss.

What remains now is Mary standing on a stone, embracing the lifeless but upright body of her Son. She cannot be said to be holding him up: her left hand rests on one of his shoulders, her barely visible right hand cradles his neck. Christ's attenuated body has become weightless. His face has been broken off, but in what little stone is left Michelangelo has incised eyes, a nose, a mouth – a face inclined in death as the Virgin's is in sorrow, both looking down into the abyss.

It is the last time Mary will touch that limp, still yielding body of her body, that head carved out of her own right shoulder. All that the earth has of love for Christ grieves with her.

Michelangelo's emulation of ancient sculpture – heroism, physical beauty, the cunning balance of forms and voids, weights and counterweights – has been definitively cast aside. This is marble not so much carved as savaged. Nor does the sculptor show us a particular moment in the narrative drama of Christ's death and entombment. This is a private investigation of love and loss. This mutilated, fathomless relic of a *Pietà* resumes all partings: Michelangelo's farewell to marble; the Virgin's last embrace of her son; the soul's anguish at separation from Christ.

Michelangelo's wetnurse was married to a stone mason, and when grown he used to say he had imbibed stone carving with her milk. He had always seen form, art's equivalent to the spirit, imprisoned in the stone block, from which it was his task to free it with his chisel. Now at the very end of his life, he destroys the marble, the material work of art itself, to release the spirit, so that his own spirit may be released and redeemed.

PART FOUR

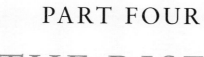

THE RISEN CHRIST

Jesus saith unto her, Touch me not:
for I am not yet ascended to my Father:
but go to my brethren, and say unto them,
I ascend unto my Father, and your Father;
and to my God, and your God.

JOHN 20:17

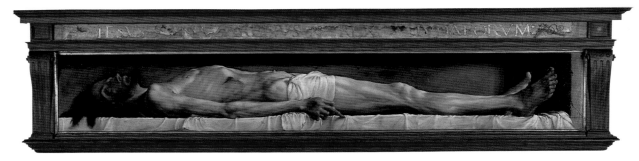

54 HANS HOLBEIN *Dead Christ*, 1521

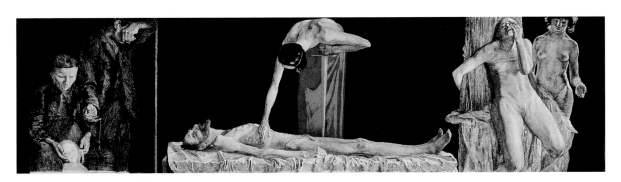

55 KÄTHE KOLLWITZ *The Downtrodden*, 1900

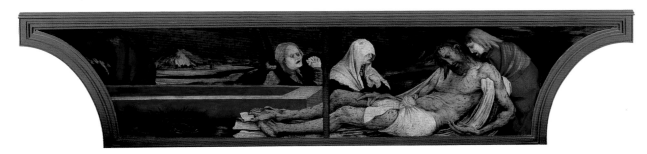

56 MATHIS GRÜNEWALD *The Entombment*, from the Isenheim Altarpiece, 1510–16

THE BODY LOWERED
AND RAISED

The body of a thin bearded man, bruised and pierced, lies on a slab [PLATE 54]. His eyes stare upwards, the lower jaw, slack in death, hangs open, as if to echo those terrible last words: 'My God my God, why hast thou forsaken me?' and 'It is finished.' As the wounds in the bruised hands and feet make plain, this is the body of Jesus of Nazareth. His life has shrunk to six feet by one – the picture is the same size as a coffin. It is a coffin.

The Roman numerals and the initials painted above his feet tell us the date and author of this image: 1521, Hans Holbein. The angle of the inscription shows that it is written as though on the short inner side of a coffin; perspective makes it seem to slope away from us. The artist who would later, in England, immortalize the majesty of a king, here depicts another king – not just a dead man, but a dead God; Jesus, the Christ. God has become man, and man has just put God brutally to death.

We have no idea where this picture was commissioned for, or how it might originally have been seen. But I think we can be sure that, like all great works of art, Holbein's *Dead Christ* now speaks to us in ways the artist can hardly have imagined. For how we react to this horrifying image depends on what we believe.

For Christians, it remains what it was when Holbein painted it: the disciples' vision of the sepulchre on that bleak Saturday which followed the Crucifixion. The moment of absolute despair, which reminds us that we must die with Christ, but also the moment which will be obliterated by the dazzling light of the Resurrection.

Even for an age without faith, for whom not only Christ but God is dead, this painted corpse still has meaning. It comes at the end of a story – and what happened before in this story, or may happen after, affects our view of the image. It reappears at the end of the nineteenth century in an etching by Käthe Kollwitz, a German artist with strong moral and social convictions but professing no religious faith. And in her art, this corpse marks the tragic conclusion of a cycle of human suffering, a story that, in spite of striving and loving, ends in the grave.

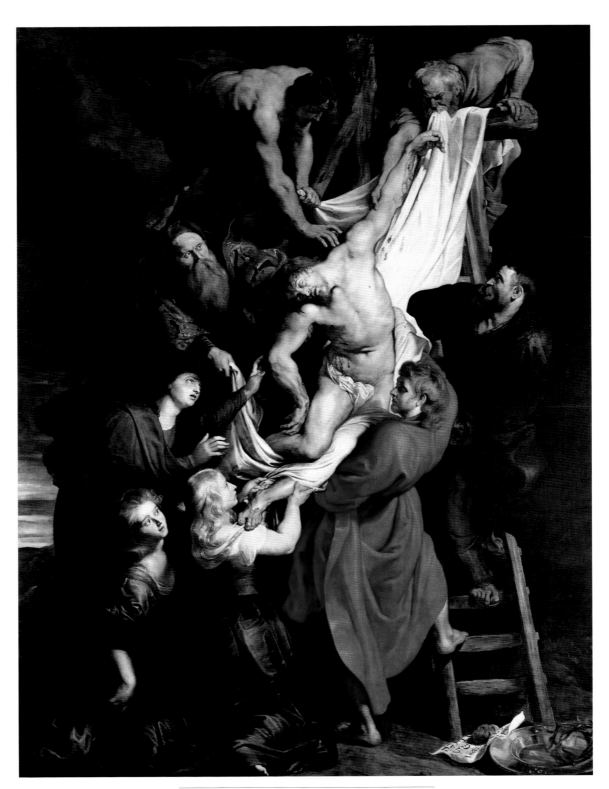

57 PETER PAUL RUBENS *The Deposition of Christ*, 1612

range, the contract was also a way of composing neighbourly differences, like who should pay for a common wall.

The arquebusiers' patron saint was Christopher, a legendary giant who sought to serve the most powerful ruler in the world. His first master, an emperor, was frightened by the devil, so Christopher switched allegiance from the emperor to Satan. But the devil in turn was frightened of a crucifix, and Christopher was converted by a wise old hermit to the service of Christ. Since he did not know how to say his prayers, the hermit set him the task of serving Christ by helping his fellow men, carrying them on his broad shoulders across a river. One dark and stormy night, Christopher heard a little child crying to him from the shore to help him across. As he carried him, the child grew so heavy that the giant nearly toppled into the raging flood. When he asked the reason why, the little boy – who was, of course, the Christ Child – answered that Christopher had been bearing the world's Master, and with him the weight of the whole world, on his back. He had found the most powerful ruler in the world.

The guild naturally wanted their altar to honour their patron saint. But the Council of Trent, in their broad reform of Christian art (see p. 118), had stipulated that altarpieces must not stray too far into the dangerous territory of saints and legends: only Christ could be represented in the central scene.

The learned, ingenious and devout Rubens made a virtue of necessity. Recalling that the name Christopher means 'bearer of Christ', he designed the entire triptych to reflect the theme of 'bearing Christ'. The outside shutters, which close over the central panel, show, on the left, the bemused giant fording the river, his cloak blowing in the wind, with a tiny Christ Child riding on his shoulder. On the right, the saintly hermit holds up a lantern to light their way. He too can be said to be bearing Christ, the Light of the World. During services, of course, the triptych would be opened, and three scenes of bearing Christ would become visible. On the left is the Visitation, when Mary pregnant with Jesus – bearing Christ – comes to visit her cousin Elizabeth, pregnant with John the Baptist:

And it came to pass, that, when Elizabeth heard the salutation of Mary, the babe leaped in her womb; and Elizabeth was filled with the Holy Ghost:

And she spake out with a loud voice, and said, Blessed art thou among women, and blessed is the fruit of thy womb.

And whence is this to me, that the mother of my Lord should come to me?

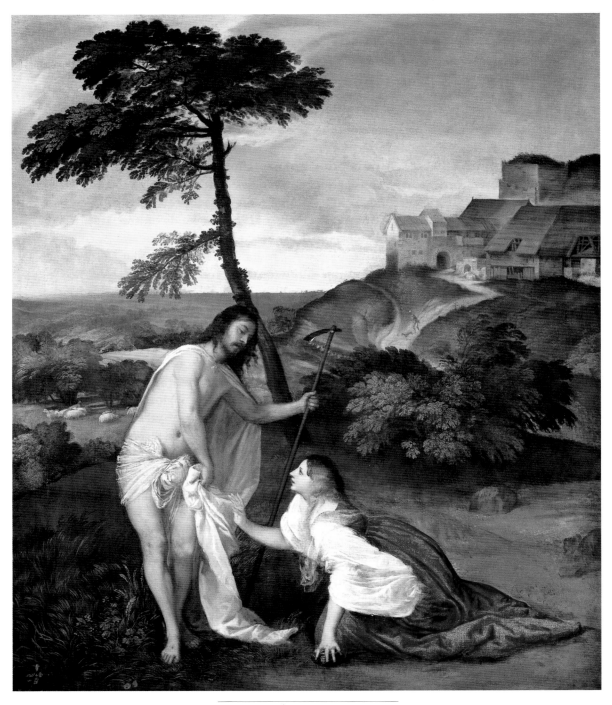

59 TITIAN *Noli me tangere, c. 1510–15*

I think we can be certain that some at least of this was consciously intended by Titian. Like most Venetians, he worked out his composition on the canvas, and traces of his earlier thinking can be seen either with the naked eye or thanks to X-rays. Originally, he may have painted Christ walking out to the left, rejecting the Magdalen's love, but not offering his own. The two backgrounds appear to have been switched at quite an advanced stage of the composition, the buildings being moved from Christ's side to Mary's. And the central tree was originally plumb in the middle, dividing the canvas unequivocally, a small lollipop-shaped affair, which Titian later hid under a grey cloud. The link between the present, slanting tree and the Magdalen, which now unites the two halves of the picture, was therefore no accident.

The picture has long been acknowledged as one of Titian's greatest creations, but it also has a distinguished place in the history of the National Gallery. When war broke out in 1939, the gallery's entire collection was evacuated to a slate mine in North Wales. Eventually, in January 1942, it was decided that every month one picture should be brought back to sustain the public, brave the bombs in Trafalgar Square and to hang alone in the gallery. Kenneth Clark, then the Director, solicited the public's views on which picture should return, and was astonished to find that the first two requests were for Titian's *Noli me tangere* and El Greco's *Agony in the Garden*.

In the bleak circumstances of the time, both choices have a striking resonance. But Clark, knowing that the *Agony in the Garden* was only a studio work, and mindful of his role as guardian of the nation's aesthetic standards, refused to let it come to London. And so the *Noli me tangere* became the first Picture of the Month, drawing such crowds that the scheme was continued for the rest of the war. Every month tens of thousands came to contemplate one picture, and returned next month to see another. In a way rarely before experienced in modern times, great paintings became part of everyday life.

High-handed though it may now seem, Clark's judgment was, I believe, entirely sound in deciding that the first Old Master painting to return to London should be the Titian. For it is a meditation not so much on an episode of Christ's life as on a constant in ours, and one that was quite inescapable in 1942. Titian has painted the moment in everyone's life when it becomes clear that love is transformed, but not diminished, by the destruction of the body. Sublime, enduring love will, with faith, bring about the impossible reunion.

Speaking to Mary Magdalene, Christ foretells his ascension to his Father in Heaven. It is effectively the opening episode of the Acts of the Apostles. Christ has chosen the followers,

*To whom also he shewed himself alive after his passion by many
infallible proofs, being seen of them forty days, and speaking of the
things pertaining to the kingdom of God ...*

*And when he had spoken these things, while they beheld, he was
taken up; and a cloud received him out of their sight.*
ACTS OF THE APOSTLES 1:3, 9

Unlike his other miraculous appearances after his death, Christ's last appearance
on earth posed an almost insoluble problem for the artist. For the important thing
about this appearance was the fact of disappearance, and as we saw in the empty
tomb, absence is hard to paint interestingly. Christ's Ascension is the final proof
that he is now 'at the right hand of God'; that we are waiting for him to come back,
and that the purpose of the Church is to prepare everyone for his Second Coming.

The art of the early Church found all this impossible to represent – and since
movement is as difficult to paint as absence, most artists continued to show the
Ascension as a static scene: Christ standing on the Mount of Olives, where the
Ascension was thought to have taken place, or seated among the clouds, with the
Apostles below. The significance of such scenes could never have been very clear
to many viewers.

As the faithful in the later Middle Ages began more actively to engage with
Christ's life, death and miracles, a new kind of image evolved – of which a little
woodcut by the great German artist Albrecht Dürer is one of the last and most
famous examples [PLATE 60].

The artist's intentions are obvious: to make us feel we are witnessing the
Ascension as the Apostles witnessed it. Christ disappears beyond the upper frame
of the print as he disappeared before their gaze, his feet and the hem of his gown
seen in perspective from below. The cloud is a mere accessory, for, as theologians
insisted, Christ is not hidden by it but disappears of his own volition. He leaves
behind him his footprints – the miraculous footprints that pilgrims to the Holy
Land flocked to see on the Mount of Olives.

The print's meaning may be profound, but the image to modern eyes cannot
help seeming absurd, as Christ vanishes from sight like a self-propelled missile.
In this instance, Dürer's art is an irrecoverable victim of the space programme.

If Christ's Ascension, his physical departure from earth, is almost impossible
to represent, his reappearance at the end of time offers magnificent pictorial
opportunities. The theology of the Second Coming has always been hard to grasp,
and, from the Gospels onwards, for this reason it has perhaps been most
powerfully expressed through images.

60 ALBRECHT DÜRER *The Ascension of Christ*, from the *Little Passion*, 1509–11

61 *Christ in Glory (The Second Coming)*, apse mosaic, Church of Sts Cosmas and Damian, Rome, *c.* 530

and iris includes a homage to the restoration's patron, Cardinal Francesco Barberini, nephew of the pope at that time: enormous bees, the heraldic emblem of the Barberini family, buzz around the flowers.

On Christ's extreme left, St Theodoric, dressed like a high Byzantine official, comes forward with his martyr's crown. He is, of course, the name saint of Queen Amalasunta's father, Felix's patron, King Theodoric of the Ostrogoths.

Below all these figures runs the River Jordan, the waters of baptism, and beneath that the Mystic Lamb stands on the mount from which spring the four rivers of Paradise inscribed with their names, Geon, Fyson, Tigris and Euphrates. Virile rams process from either side towards the Lamb. These are the twelve apostolic sheep, issuing from two cities whose names are clearly marked: Jerusalem on our left (also remodelled in Cardinal Barberini's restoration) and Bethlehem on our right.

The mosaic is of the highest quality of Late Antique art, with smaller and more tightly set fragments of glass than the Byzantine mosaics of Ravenna, giving it a more naturalistic appearance, closer to that of painting. Because of this, and because Cosmas, Damian and Theodoric were all Syrian saints, it is thought that Pope Felix employed craftsmen from Antioch in Syria. The city, famed for its mosaic workshops, was devastated by a catastrophic earthquake in 526, the very year when the work was projected; surviving artists and artisans might well have been glad to emigrate.

But of greater interest is the effect these probable Syrian origins had on the face of Christ as it appears in this mosaic. Unlike the clean-shaven Byzantine Christ-Emperor at San Vitale in Ravenna, this Christ is a fully bearded Syrian monarch, anticipating the bearded, though less robust, True Likenesses imported some centuries later from the Near East. The apse mosaic in Sts Cosmas and Damian came to be viewed as an archetype of the image of the Second Coming, and – though never equalled – was emulated in many later Roman churches.

And indeed, when the original doors to the church – which face due west, directly in front of the apse – were open to the afternoon sun, the mosaic would have been, literally, dazzling. Much of it is made with tesserae of gold leaf fused with glass; some are set with the gold leaf outwards, others with the gold embedded in the plaster, creating a permanent shimmer. The clouds seem aflame with every colour of the sunset, and Christ advances upon them: 'For as the lightning cometh out of the east, and shineth even unto the west; so shall also the coming of the Son of man be' (Matthew 24:27).

The mosaic in Sts Cosmas and Damian is a supreme vision of the glory of the coming of the Lord, a prophetic image of the ultimate triumph of Christ. It is also,

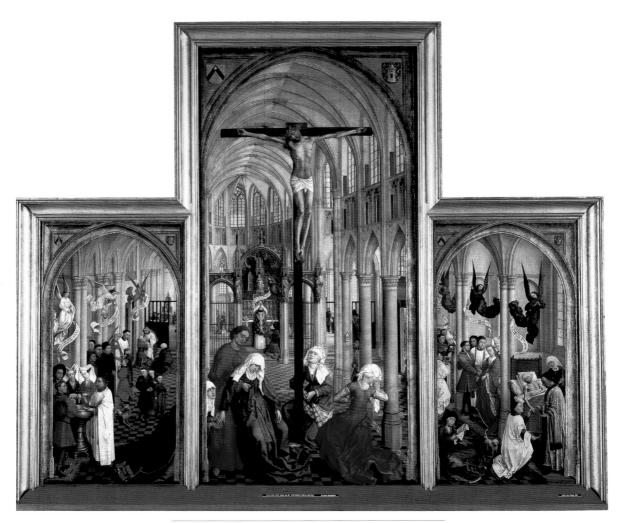

62 ROGIER VAN DER WEYDEN *The Seven Sacraments*, 1460s
(OPPOSITE) Detail showing left panel

63 LUCAS CRANACH THE YOUNGER *The Crucifixion (Allegory of Redemption)*, 1555

64 JUAN DE VALDÉS LEAL *Finis Gloria Mundi* ('The End of Worldly Glory'), 1671–2

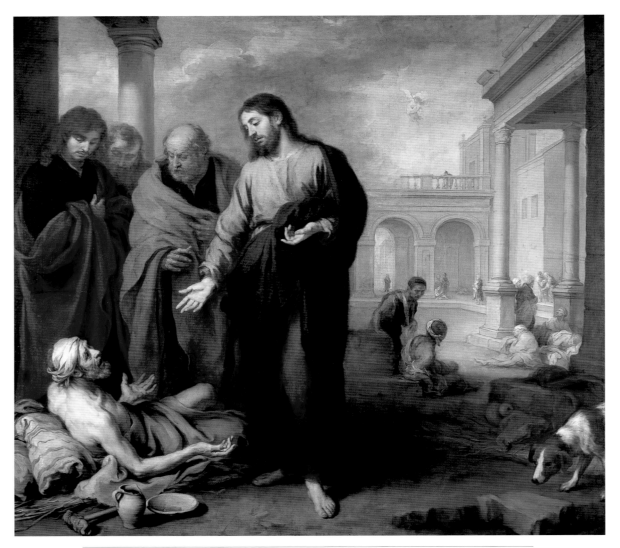

65 BARTOLOMÉ ESTEBAN MURILLO *Christ Healing the Paralytic at the Pool of Bethesda*, 1667–70

In 1812 Napoleon's generals looted the church, and carried off to France the other four Works of Mercy painted by Murillo. They were sold and are now in museums abroad. Giving hospitality to strangers is represented by Abraham entertaining angels unawares (Genesis 18:1–19). Clothing the naked is shown by the return of the Prodigal Son, when the forgiving father 'said to his servants, Bring forth the best robe, and put it on him; and put a ring on his hand, and shoes on his feet' (Luke 15:22).

Visiting those in prison is the angel freeing St Peter from prison (Acts 12:1–11), while ministering to the sick is *Christ Healing the Paralytic at the Pool of Bethesda* [PLATE 65].

> *Now there is at Jerusalem by the sheep market a pool, which is called in the Hebrew tongue Bethesda, having five porches.*
>
> *In these lay a great multitude of impotent folk, of blind, halt, withered, waiting for the moving of the water.*
>
> *For an angel went down at a certain season into the pool, and troubled the water: whosoever then first after the troubling of the water stepped in was made whole of whatsoever disease he had.*
>
> *And a certain man was there, which had an infirmity thirty and eight years.*
>
> *When Jesus saw him lie, and knew that he had been now a long time in that case, he saith unto him, Wilt thou be made whole?*
>
> *The impotent man answered him, Sir, I have no man, when the water is troubled, to put me into the pool: but while I am coming, another steppeth down before me.*
>
> *Jesus saith unto him, Rise, take up thy bed, and walk.*
>
> *And immediately the man was made whole, and took up his bed, and walked.*
>
> JOHN 5:2–9

This Bethesda is not far from Spain: Murillo includes a humble Sevillian earthenware jug and plate, and the poor paralytic could be one of those unfortunates whose care was specifically urged in the instructions given to the brethren of Holy Charity:

> *And whereas the poor and destitute, falling ill, often get so weak that they frequently die in the streets, we order that whenever any of our brothers comes upon such an occurrence, he will attempt to find out*

67 ROGIER VAN DER WEYDEN *The Last Judgment*, Hôtel-Dieu, Beaune, 1443–51
(OPPOSITE) Detail showing centre

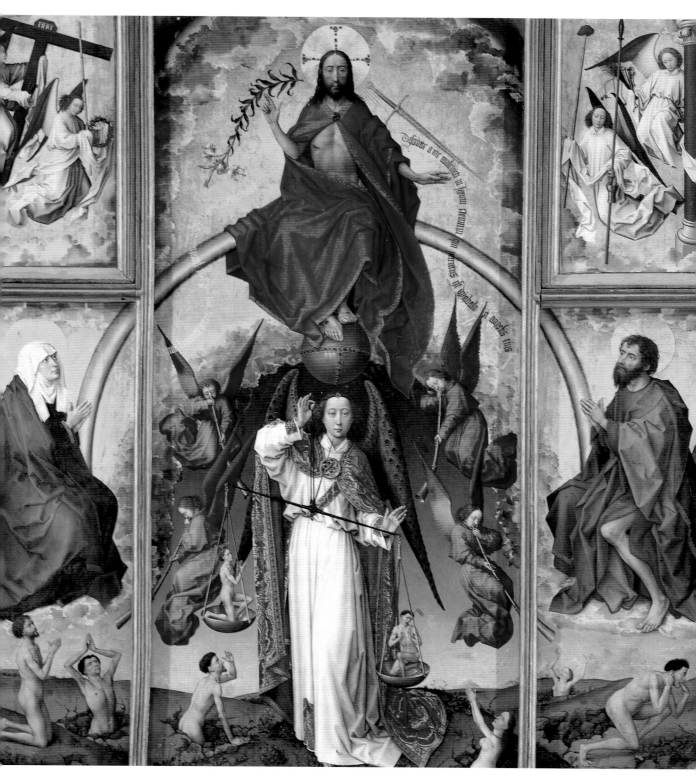

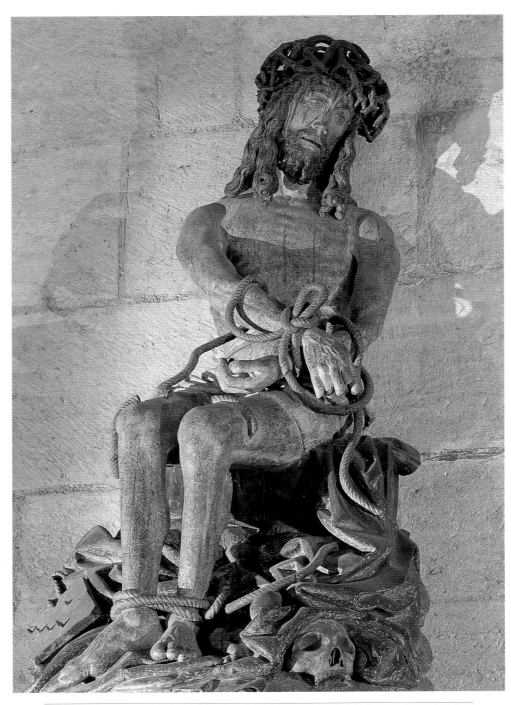

68 *Christ on the Cold Stone (Le Christ au Liens)*, Hôtel-Dieu, Beaune, mid-fifteenth century

thorns, hands and feet bound with rope, sitting on a stone on Calvary waiting to be nailed to the Cross. It is an image of the utmost desolation.

When a patient entered his death agony, the nuns used to light a candle on the holder that still can be seen by the side of this figure, through a little window leading to their dormitory from which they could watch over the ward at night. Christ's presence, it was thought, would console the dying and help them resign themselves to their suffering.

Since Rogier's *Last Judgment* was removed, only this suffering Christ remains watching over this space made for the sick and the poor. Splitting up such a coherent whole has meant a serious loss. But there can be no doubt that the present arrangement precisely mirrors the religious (or rather, secular) assumptions of our time. Few visitors to Beaune now live their lives in dread of the Last Judgment, but most acknowledge our obligations to the sick and the destitute. The high theology of Christ the Judge may have been set aside, relegated to a separate, purely cultural space, but human suffering still speaks to us, in whatever form the artist presents it.

And that is perhaps why it was possible for a twentieth-century Christian artist to design an altarpiece of the General Resurrection with reference to Christ and the Cross, but ostensibly none to the Last Judgment [PLATE 69].

The painter Stanley Spencer, unlike the commissioned officers Owen and Sassoon (see pp. 119; 121), spent the entire First World War as a private soldier: first as a medical orderly at the Beaufort War Hospital near Bristol, then with the 68th Field Ambulancers in Macedonia, and finally on active service in the front line with the 7th Battalion of the Royal Berkshire Regiment. Like these war poets, and so many others, he interpreted his war experiences in religious terms, or – more accurately – his religious vision in terms of his war experiences.

A *Crucifixion* of 1921, now in Aberdeen, is set on a steep and barren mountainside. Of it Spencer wrote: 'The memory I had of some mountain ... dividing Macedonia from Bulgaria ... as I walked towards the range ... every sound was muffled ... and only the faint jingle and squeaking of the mules' harnesses.' By 1923 Spencer had evolved a whole architectural scheme for a chapel with 'acres of Salonica and Bristol war compositions', when he was visited by Mr and Mrs J. L. Behrend. Mrs Behrend's brother, Lieutenant Henry Willoughby Sandham, had died in 1919 as a result of an illness contracted during the Macedonian campaign. The Behrends decided to commission Spencer's chapel as a private memorial to him, and it was built near their house in the Hampshire village of Burghclere.

The Oratory of All Souls Sandham Memorial Chapel is decorated by a mural

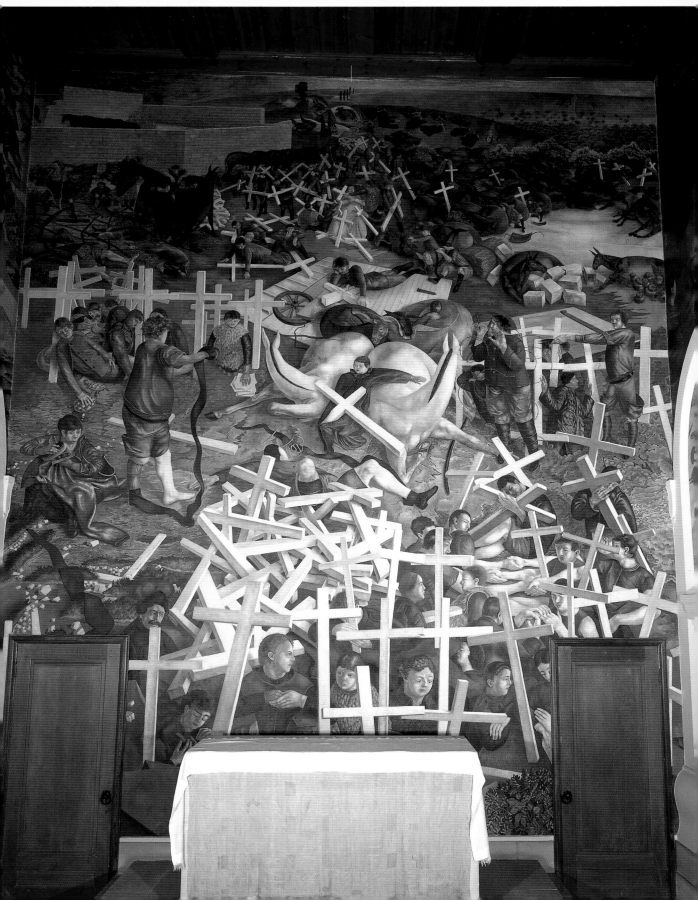

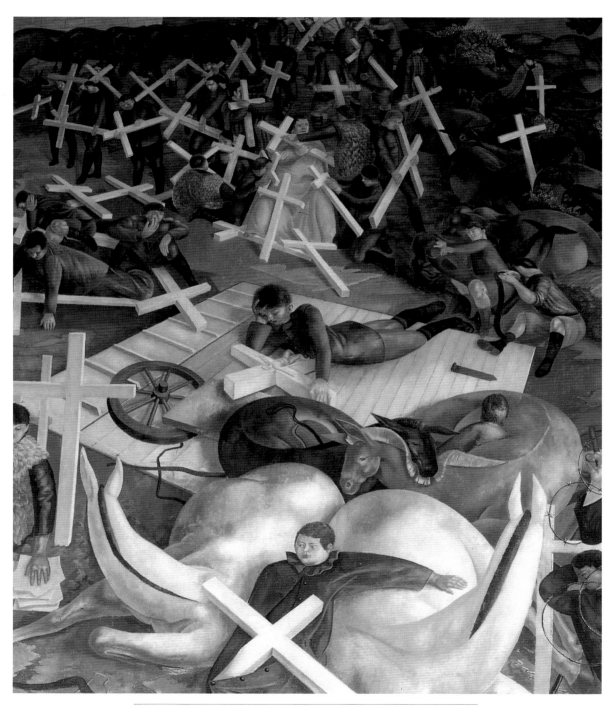

69 (OPPOSITE) STANLEY SPENCER *The Resurrection of the Soldiers*, 1928–9
(ABOVE) Detail showing centre

pocket: 'I had to go to war … I had to see it all with my own eyes … the hunger,
the fleas, the mud, the shitting in one's pants with fear … To be crucified, to expe-
rience the deepest abyss of life …' He was to remain loyal to the philosopher of
his youth, continuing into old age to affirm life, a 'monster of force' beyond good
and evil, even in its most destructive aspects:

> *War is horrible: hunger, lice, mud, terrifying noises. It is all completely
> different. You see, before the early paintings, I had the feeling that there
> was a dimension of reality that had never been dealt with in art: the
> dimension of ugliness. The war was a dreadful thing, but there was
> something awe-inspiring about it. There was no question of me missing
> out on that! You have to have seen people out of control in that way to
> know anything about man.*

Between November 1915 and December 1916 Dix saw service in Champagne, in
the trenches of Artois, and on the Somme, where he was involved in two major
battles. He noted in his diary: 'Lice, rats, barbed wire, fleas, shells, bombs, under-
ground caves, corpses, blood, liquor, mice, cats, gas, artillery, filth, bullets,
mortars, fire, steel: that is what war is! It is all the work of the Devil!' In 1927,
perhaps the most successful painter of the Weimar Republic, he returned to
Dresden as professor at the city's illustrious Art Academy. In 1933, after Hitler
came to power, he was sacked without notice and banned from exhibiting
his work.

The main reason for his dismissal was this horrific painting, exhibited in
Berlin in 1932, and some preliminary etchings and oils:

> *The painting began life ten years after the First World War. In the
> meantime, I had done a lot of preliminary studies, looking at ways of
> dealing with the war in my paintings. In 1928, after I had been working
> on the subject for several years, I finally felt ready to tackle it properly.
> At that point, incidentally, there were a lot of books circulating in
> the Weimar Republic, promoting a notion of heroism which, in the
> trenches, had long since been rejected as an absurdity. People were
> already beginning to forget the terrible suffering the war had caused.
> That was the situation in which I painted the triptych.*

The *War Triptych*'s deliberate echoing of the Isenheim Altar places both artist and
painting within the great tradition of German Expressionism – but what else is

Dix saying in adapting to the secular ends of Weimar Republic politics the visual language of Christian theology?

Kollwitz, as we saw in Chapter Ten, equated the downtrodden of society with Jesus the innocent victim. Dix's work is more complex, and harder to interpret with confidence.

In the left wing, 'dawn breaks open like a wound that bleeds afresh'. Soldiers shoulder their heavy rifles going into battle through the mist, like so many anonymous images of Christ carrying his Cross on the road to Calvary. The association is strengthened through the gun-carriage wheel, an earthbound Chi Rho wreathed in cold steel.

A whole village has been reduced to ruin, and many men have suffered and died horrific deaths, in the central noon-time panel. Grünewald's crucified Christ lies upside down on a pile of corpses. His bullet-scarred legs protrude into a sky darkened by gunfire smoke. Pointing to him with a skeletal index finger, a cadaver impaled on a blasted tree plays St John the Baptist. One survivor stands, his face hidden by a gas mask, watching the dead 'Dim, through the misty panes and thick green light, As under a green sea …' Below, another masked man, invisible in reproduction, stares out, 'Cramped in that funnelled hole',

> *… one of the many mouths of Hell*
> *Not seen of seers in visions, only felt*
> *As teeth of traps; when bones and the dead are smelt*
> *Under the mud where long ago they fell*
> *Mixed with the sour sharp odour of the shell.*

Owen had fallen through a shell-hole into a cellar, and was trapped there for three days. Dix, interviewed in 1965, related: 'For years, for a good ten years, I had these dreams, in which I had to crawl through ruined houses with passageways I could hardly squeeze through. I dreamt continuously about rubble and ruins.'

Almost hidden among the impasted painted blood and mud lies a severed head, crowned with barbed wire. In the predella below, soldiers in the pose of Holbein's *Dead Christ* sleep, awaiting not Resurrection but a return to the trenches and the battlefield. The cloth slackly suspended above them holds their rations, to keep them from the rats.

For the right, night-time wing, Dix originally painted a composition of *Trench Warfare*, where a living soldier treads on the head of a dead one. He later replaced this with the present image, reminiscent of a Deposition from the Cross:

70 OTTO DIX *War Triptych*, 1929–32

a soldier with the artist's own features lifts up a wounded comrade. Like Spencer, though in a quite different key, Dix concludes on a note of human charity.

Many viewers see the painting as expressing Nietzschean pessimism. Rejecting the theologians' view of man as the image of God, and the philosophers' view of him as a rational being, it seems to show men trapped in a never-ending cycle of destruction, which the artist must not flinch from depicting. Yet whatever our religious beliefs, our responses to an image like this are still conditioned by the centuries of Christian art we have briefly been surveying.

If Nietzsche's is a world without God, and this a Crucifixion without Christ, the Passion not of one man but of many, this image – like any traditional Crucifixion – still confronts the spectator with the centuries-old questions: how far is this unspeakable suffering my fault? And will I have the courage and generosity to make it less by picking up my fallen comrade?

71 REMBRANDT *Nunc Dimittis (Simeon Holding the Christ Child),* c. 1669

EPILOGUE

In a world without God, is there still a future for the image of Christ?

No longer dreading Judgment, we do not picture him as Ruler and Judge.

Crucifixes may be ubiquitous, but since the First World War the imagery of suffering has become steadily richer with photographs of real people and real events. Since many of those who suffer most today are not Christians, it is hard now to view the Crucifixion as an emblem of universal suffering. The crosses outside Auschwitz were seen to have been put up to call Jewish suffering into question – or worse – and were decried for that reason. And perhaps the scale of suffering has come to seem too great, and a creed of atonement too remote, for a suffering God to speak to many of redemption, or move us to acts of charity. Americans looked with horror and remorse at the news photograph of a Vietnamese child burned with napalm. As earlier centuries might have reacted to an altarpiece of the Crucifixion, they knew that this suffering was in a general sense their fault and that their actions could help to alleviate the wider injustice and suffering that it represented. And it was this image, and not one of Christ on the Cross, that provided an impetus for bringing the war to an end. Yet you could argue that, in a way, this speaks to the continuing power of the tradition we have been examining: the Franciscan response of pity, followed by contrition and then action was actively present, but the trigger was not a suffering god, but a suffering child. As Francis had argued over seven centuries earlier, it is the love all of us can feel for a child that recalls us most powerfully and most simply to our highest duties of love for all humanity. And nothing will ignite that love more rapidly than an affecting image.

If Mark Wallinger still invokes the *Ecce Homo*, many Western artists today, believers and unbelievers, try to represent the divine and the spiritual in different ways. Some, as Mark Rothko did, return to the aniconic traditions of observant Jews and iconoclasts, depicting the transcendental as radiance or luminous fields of colour. Others seek universality by combining Western and foreign traditions. Stephen Cox, an English sculptor responsible for the altar and reredos of St Paul's,

Haringay, has been inspired by images of divinity in traditional Indian stone carving. The American video artist Bill Viola turns to the writings of Western and Eastern mystics and Jungian psychoanalysis. His installation at Durham Cathedral, *The Messenger*, associates a Christ-like male nude with the Sanskrit concept of *prana*, the breath which animates, the life force – and this itself goes back to pagan Greek and heretic early Christian notions.

But if we no longer heed the messages of the great Christian images of the past, and admire them mainly for their aesthetic qualities, there is one traditional image of Christ that, I believe, remains universally valid. It moves people from any cultural background, whether or not they recognize it as an image of the incarnate God.

It is the Christ Child. Like all babies, the infant Christ is the focus of our aspirations and our apprehensions. We know what he will have to endure, and we want to protect him from it. If there is one emotion that can come close to uniting all humanity, it is surely awe in the face of a new-born child – tender, overwhelming, humbling, strengthening. No artist ever painted it more powerfully than Rembrandt in the picture now in the museum in Stockholm [PLATE 71].

The Child's parents have just handed him to Simeon, the priest in the Temple. And although he appears to be blind, he sees the essential. He intuits divinity and he knows all will now be well. You will remember the text from Chapter Two of St Luke's Gospel (see p. 184). Rembrandt, as so often, concentrates on the heart of the matter; he shows the scene in cinematic close-up. Simeon is transfigured; in his arms he holds Christ. But he and Anna, the aged prophetess (a figure added by a later artist), appear like any grateful grandparents near the end of their days, and Christ is every baby: a newborn child whom all are moved to protect and love, and on whom all hopes are fixed, until the last generation.

Lord, now lettest thou thy servant depart in peace ... For mine eyes have seen thy salvation.

NOTES ON SOURCES

CHAPTER TWO
Page 40
'In Cosimo's chapel there were painted...' Gentile Becchi, quoted in C.A. Luchinat, *The Chapel of the Magi: Benozzo Gozzoli's Frescoes in the Palazzo Medici-Riccardi, Florence*, London and New York, 1994

CHAPTER THREE
Page 49
'If you desire us to celebrate...' Tommaso of Celano, quoted in *The Little Flowers, Legends and Lauds. St Francis of Assisi and others*, edited by Otto Karrer, trans. N. Wydenbruck, Sheed & Ward, London, 1947

CHAPTER FOUR
Page 63
'The king goes astray if he thinks...' Address by William of Orange to fellow noblemen in 1564, quoted in Bob Haak, *The Golden Age: Dutch Paintings of the 17th Century*, Thames & Hudson, London, 1984

CHAPTER FIVE
Page 68
'We little fishes...' Tertullian, quoted in *The Early Christian Fathers*, edited and trans. by Henry Bettenson, Oxford University Press, Oxford, 1956
Page 76
' by a lantern...' William Holman Hunt, quoted in *The Pre-Raphaelites*, Tate Gallery/Penguin Books, London, 1984
Page 76
'He who when...' Ibid.
Page 80
'Everyone knows...that the Father is greater...' Arius, quoted in *Documents of the Christian Church*, selected and edited by Henry Bettenson, Oxford University Press, Oxford, 1967

CHAPTER SIX
Page 88
'when he saw Christ...' The legend of the Mandylion, quoted in Ian Wilson, *The Turin Shroud*, Victor Gollancz, London, 1978
Page 97
'our foul, black, shameful deeds', Julian of Norwich, *Revelations of Divine Love*, trans. by Elizabeth Spearing, Penguin Books, London, 1998
Page 97
'Nor is it without...' Matthew of Janov, *Rules of the Old and New Testament*, c. 1390, quoted in Hans Belting, *Likeness and Presence: A History of the Image before the Era of Art*, Chicago University Press, Chicago, 1994
Page 101
'The picture makes...' Aristocratic journalist, quoted in Ian Wilson, op. cit.
Page 102
'The face and body...' Ian Wilson, op. cit.
Page 104
'If an image has...' Matthew of Janov, quoted in Hans Belting, op. cit.
Page 110
'As, when upon His drooping head...' Poem by John Keble printed in the Exhibition Catalogue, 1860, quoted in *The Pre-Raphaelites*, op. cit.
Page 115
'The sculpture's enigmatic...' Adrian Searle, *The Guardian*, 22 July 1999

CHAPTER SEVEN
Page 119
'One ever hangs...' Wilfred Owen, 'At a Calvary near the Ancre', Wilfred Owen, *The War Poems*, edited by Jon Stallworthy, Chatto & Windus.
© The Executors of Harold Owen's Estate 1963 and 1983.
Page 121
'Already I have comprehended...' Letter of 2 May 1917, Wilfred Owen, *Collected Letters*, edited by Harold Owen and John Bell, Oxford University Press, Oxford, 1967
Page 121
'The unreturning army that was youth...' Siegfried Sassoon, 'Prelude: The Troops', *Penguin Book of First World War Poetry*, The Viking Press, London, 1979. Reproduced by permission of Mr G.T. Sassoon and The Viking Press.
Page 128
'to be alive, before he had died...' Mateo Vazquez de Leca, quoted in Beatrice Gilman Proske, *Martinez Montañés: Sevillian Sculptor*, New York, 1967

Page 128
'I have a great desire...' Ibid.

CHAPTER EIGHT

Page 144
'It happened that...' Teresa of Avila, *Life of the Holy Mother Teresa of Jesus*, Sheed & Ward, London, 1944 and 1979

Page 145
'The figures are of...' Mme d'Aulnoy, 1679, quoted in Susan Verdi Webster, *Art and Ritual in Golden Age Spain*, Princeton University Press, Princeton, 1998

Page 145
'The face has...' Albert Calvert, quoted in Webster, op. cit.

page 145
'The fictitious came....' Santiago Alcolea, *Spanish Sculpture*, New York, 1969, quoted in Webster, op. cit.

Page 145
'Sculpture has existence...' Francisco Pacheco, quoted in Webster, op. cit.

Page 146
'If there is anything...' Fray Jesús de Maria, quoted in Webster, op cit.

Page 149
'His chief ailment was...' Teresa of Avila, op. cit.

CHAPTER NINE

Page 166
'the most beautiful marble...' Jacopo Galli, quoted in John Pope-Hennessy, *Italian High Renaissance and Baroque Sculpture*, 2nd ed., Phaidon, London, 1970

Page 168
No portrayal of a corpse...' Giorgio Vasari, 'The Life of Michelangelo' in *Lives of the Artists*, first published in Italian in 1550 and substantially enlarged in 1568

Page 168
'Vergine madre...' Dante, *The Divine Comedy*, Paradise, Canto 33

Page 173
'Once Vasari was sent...' Vasari, 'The Life of Michelangelo', op. cit.

Page 174
'It was now necessary...' Ibid.

CHAPTER ELEVEN

Page 209–11
'And whereas the poor...' Rule for the Caridad, quoted in Jonathan Brown, *Images and Ideas in Seventeenth-Century Spanish Painting*, Princeton University Press, Princeton, 1978

Page 217
'The memory I had...' Stanley Spencer, quoted in Duncan Robinson, *Stanley Spencer at Burghclere*, The National Trust, London, 1991

Page 218
'ordinary experiences or happenings...' Ibid.

Page 218
'a sort of portrait gallery...' Ibid.

Page 219
'For 14 hours yesterday...' Wilfred Owen to Osbert Sitwell, 4 July 1918, quoted in *Poems of Wilfred Owen*, ed. C. Day Lewis, Chatto & Windus, London, 1964

Page 222
'I had to go to war...' Otto Dix, quoted in Eva Karcher, *Dix*, Bonfini Press, New York, 1987

Page 222
'War is horrible...' Ibid.

Page 222
'Lice, rats, barbed wire...' Ibid.

Page 222
'The painting began life...' Ibid.

Page 223
'Cramped in that funnelled hole...' *The Poems of Wilfred Owen*, edited by Edmund Blunden, Chatto & Windus, London, 1931. Reproduced by permission of the Estate of Wilfred Owen & Chatto & Windus

Page 223
'For years, ...' Otto Dix, quoted in Karcher, op. cit.

FURTHER READING

National Gallery, *The Image of Christ*, edited by G. Finaldi, catalogue to accompany the exhibition *Seeing Salvation*, National Gallery, London, 2000

GENERAL BOOKS

Beckwith, J., *Early Christian and Byzantine Art*, 2nd ed., Harmondsworth, 1979

Belting, H., *Likeness and Presence: A History of the Image before the Era of Art*, Chicago, 1994

Belting, H., *The Image and Its Public in the Middle Ages: Form and Function of Early Paintings of the Passion*, New Rochelle, 1990

Bonaventure, (Pseudo-), *Meditations on the Life of Christ: an illuminated manuscript of the fourteenth century*, translated by Isa Ragusa, edited by I. Ragusa and R. B. Green, Princeton, 1961

Campbell, L., *National Gallery Catalogues: The Fifteenth-Century Netherlandish Schools*, London, 1998

Cormack, R., *Painting the Soul: Icons, Death Masks and Shrouds*, London, 1997

Cross, F. L. and Livingstone, E. A., *The Oxford Dictionary of the Christian Church*, 2nd revised ed., Oxford, 1983

Drury, J., *Painting the Word: Christian Pictures and their Meanings*, London, 1999

Dunkerton, J., Foister, S., Gordon, D. and Penny, N., *Giotto to Dürer: Early Renaissance Painting in the National Gallery*, London, 1991

Dunkerton, J., Foister, S. and Penny, N., *Dürer to Veronese: Sixteenth-Century Painting in the National Gallery*, London, 1999

Ferguson, G., *Signs and Symbols in Christian Art*, Oxford, 1954

Freedburg, D., *The Power of Images*, Chicago, 1989

Hall, J., *Hall's Dictionary of Subjects and Symbols in Art*, London, 1974

Langmuir, E., *The National Gallery Companion Guide*, London, 1994

Lowden, J., *Early Christian and Byzantine Art*, London, 1997

Mâle, E., *Religious Art in France: The Late Middle Ages*, reprinted Princeton, 1986

Mâle, E., *Religious Art in France: The Thirteenth Century*, reprinted Princeton, 1984

Mâle, E., *Religious Art in France: The Twelfth Century*, reprinted Princeton, 1978

Marrow, J. H., *Passion Iconography in Northern European Art of the Late Middle Ages and Early Renaissance*, Brussels, 1979

Pelikan, J., *The Illustrated Jesus through the Centuries*, New Haven and London, 1997

Rijksmuseum, *The art of devotion in the late Middle Ages in Europe, 1300–1500*, edited by H. W. van Os, exhibition catalogue, Rijksmuseum, Amsterdam, 1994

Ringbom, S., *Icon to Narrative: The Rise of the Dramatic Close-up in Fifteenth-Century Devotional Painting*, Abo, 1965

Schiller, G., *The Iconography of Christian Art*, first 2 vols in English, London, 1971 and 1972

Southern, R. W., *The Making of the Middle Ages*, London 1967

Steinberg, L., *The Sexuality of Christ in Renaissance Art and in Modern Oblivion*, Chicago, 2nd revised ed., 1996

Swanson, R. N., *Religion and Devotion in Europe, c.1215–c.1515*, Cambridge, 1995

BOOKS ON INDIVIDUAL ARTISTS AND SUBJECTS

CHAPTER TWO

Luchinat, C. A., *The Chapel of the Magi: Benozzo Gozzoli's Frescoes in the Palazzo Medici-Riccardi Florence*, London and New York, 1994

Simson. O. von, *The Sacred Fortress* (Ravenna), Chicago, 1948

Stevenson, J., *The Catacombs: Rediscovered Monuments of Early Christianity*, London, 1978

Trexler, R. C., *The Journey of the Magi: Meanings in History of a Christian Story*, Princeton, 1997

CHAPTER THREE

Conisbee, P., *Georges de La Tour and his World*, Washington, 1996

National Gallery of Art, *Georges de La Tour* exhibition catalogue, National Gallery of Art, Washington, 1996

CHAPTER FOUR

Gibson, W. S., *Bruegel*, London, 1977

Grossmann, F., *Pieter Bruegel*, London, 1973

CHAPTER FIVE

Amor, A. C., *William Holman Hunt: the true Pre-Raphaelite*, London, 1989

Maas, J., *Holman Hunt and The Light of the World*, London, 1984

Tate Gallery, *The Pre-Raphaelites*, exhibition catalogue, Tate Gallery, London, 1984

CHAPTER SIX

Cameron, A., *The Sceptic and the Shroud*, King's College, London, 1980

Heydenreich, L. H., *Leonardo: The Last Supper*, London, 1974

Kuryluk, E., *Veronica and her Cloth*, Oxford, 1991

Pointon, M., *William Dyce, 1806–1864: a critical biography*, Oxford 1979

Wilson, I., *The Turin Shroud*, London, 1978

CHAPTER SEVEN

Hayum, A., *The Isenheim Altarpiece: God's Medicine and the Painter's Vision*, Princeton, 1993

Metropolitan Museum, *Zurbarán*, edited by J. Baticle, exhibition catalogue, Metropolitan Museum of Art, New York, 1987

Pevsner, N. and Meier, M., *Grünewald*, London, 1958

CHAPTER EIGHT

Hood, W., *Fra Angelico at San Marco*, New Haven and London, 1993

Proske, B. G., *Martinez Montañés: Sevillian Sculptor*, New York, 1967

Webster, S. V., *Art and Ritual in Golden Age Spain*, Princeton, 1998

CHAPTER NINE

National Gallery, *Rembrandt: The Master and his Workshop: Drawings and Etchings*, edited by H. Bevers, P. Schatborn and B. Welzel, exhibition catalogue, National Gallery, London, 1992

Pope-Hennessy, J., *Italian High Renaissance and Baroque Sculpture*, 2nd ed., London, 1970

Weinberger M., *Michelangelo: The Sculptor*, London and New York, 1967

White, C., *Rembrandt as an Etcher*, 2nd revised ed., New Haven and London, 1999

CHAPTER TEN

Bätscmann, O. and Griener, P., *Hans Holbein*, London, 1997

MacGregor, N., 'To the Happier Carpenter': Rembrandt's war-heroine Margaretha de Geer, the London public and the right to pictures, Groningen, 1995

Martin, J. R., *Rubens: The Antwerp Altarpieces*, London, 1969

Rowlands, J., *Holbein: The Paintings of Hans Holbein the Younger. Complete Edition,* London and Boston, 1985

White, C., *Peter Paul Rubens: Man and Artist*, New Haven and London, 1987

CHAPTER ELEVEN

Bell, K., *Stanley Spencer: A Complete Catalogue of Paintings*, London, 1992

Brown, J., *Images and Ideas in Seventeenth-Century Spanish Painting*, Princeton, 1978

Davies, M., *Rogier van der Weyden*, London, 1972

De Vos, D., *Rogier van der Weyden: The Complete Works*, New York, 1999

Friedländer, M. J. and Rosenberg. J., *Lucas Cranach*, London, 1978

Karcher, E., *Dix*, New York, 1987

Robinson, D., *Stanley Spencer at Burghclere*, National Trust, London, 1991

Royal Academy, *Bartolomé Esteban Murillo: 1617-1682*, exhibition catalogue, Royal Academy, London, 1982

Tate Gallery, *Otto Dix 1891–1969*, exhibition catalogue, Tate Gallery, London, 1992

ILLUSTRATIONS

43 *Christ of Clemency*, 1603
 Juan Martínez Montañés, 1568–1649
 Polychromed wood
 Cathedral, Seville, Spain
44 *Jesús de la Pasión*, c.1619
 Juan Martínez Montañés, 1568–1649
 Polychromed wood, clothed
 San Salvador, Seville, Spain
45 *'El Señor de los Temblores' carried in Procession during the Earthquake of 1650* (detail), seventeenth century
 Unknown Cuzcanian artist
 Oil on canvas
 Cathedral, Cuzco, Peru
46 *St Dominic at the Foot of the Cross*, c.1441–3
 Fra Angelico, 1395/1400–1455
 Fresco 340 x 155 cm.
 Cloister of San Marco, Florence, Italy
47 *The Mocking of Christ*, c.1441–3
 Fra Angelico, 1395/1400-1455
 Fresco, 195 x 159 cm.
 Cell 7, San Marco, Florence, Italy
48 *Elements of the Passion*, c.1330-40, four pages from a devotional book
 Top left: Christ with one of his tormentors, the hand that struck him.
 Top right:The Crown of Thorns, the wound in Christ's side, the bucket of vinegar and staff with the sponge offered to Christ to drink on the Cross.
 Above left:The three nails and hammer with which Christ was fastened to the Cross, the pincers for removing the nails, the cloth with which Christ was blindfolded, the thirty pieces of silver for which he was betrayed by Judas, three bloody footprints from Christ's journey to Golgotha.
 Above right: Christ's cloak and the three dice with which soldiers gambled for it, a stick or the reed which Christ was given to hold as a sceptre, a whip, the ladder used to take Christ down from the Cross, the spear that pierced his side, Christ's tomb seen from above.
 Unknown German artist from the Lower Rhine or Westphalia
 Painted and gilded elephant ivory, 10.5 x 5.9 cm.
 Victoria and Albert Museum, London, UK

CHAPTER NINE
49 *Three Crosses*, third state, 1653
 Rembrandt, 1606–69
 Etching, 38.5 x 45 cm.
 British Museum, London, UK
50 *Three Crosses*, fourth state, after 1653
 Rembrandt, 1606–69

Etching, 38.5 x 45 cm.
British Museum, London, UK
51 *Pietà*, 1497–1500
 Michelangelo Buonarroti, 1475–1564
 Marble, height 174 cm., width 195 cm.
 St Peter's, Vatican, Rome, Italy
52 *Pietà*, begun c.1545, abandoned 1555
 Michelangelo Buonarroti, 1475–1564
 Marble, height 226 cm., width of base 123 cm., depth of base 94 cm.
 Museo dell' Opera del Duomo, Florence, Italy
53 *Rondanini Pietà*, unfinished at artist's death, 1564
 Michelangelo Buonarroti, 1475–1564
 Marble, height 195 cm.
 Castello Sforzesco, Milan, Italy

CHAPTER TEN
54 *Dead Christ*, 1521
 Hans Holbein, 1497/8–1543
 Tempera on limewood, 30.5 x 200 cm.
 Kunstmuseum, Öffentliche Kunstsammlung, Basle, Switzerland
55 *The Downtrodden*, 1900
 Käthe Kollwitz, 1867–1945
 Etching, third state, 22.8 x 19.5 cm.
 Collection of Dr Richard A. Simms, Los Angeles, California, USA
56 *The Entombment*, from the Isenheim Altarpiece, 1510–16
 Mathis Grünewald, 1475/80–1528
 Oil on limewood, 269 x 307 cm.
 Musée d'Unterlinden, Colmar, France
57 *The Deposition of Christ*, 1612
 Peter Paul Rubens, 1577–1640
 Oil on panel, 420 x 310 cm., central panel of a triptych
 Cathedral, Antwerp, Belgium
58 *The Resurrection*, from the Isenheim Altarpiece, 1510–16
 Mathis Grünewald, 1475/80–1528
 Oil on limewood, 269 x 143 cm.
 Musée des Beaux Arts, Colmar, France
59 *Noli me tangere*, c. 1510–15
 Titian, active c. 1506; died 1576
 Oil on canvas, 108.6 x 90.8 cm.
 National Gallery, London, UK
60 *The Ascension of Christ*, from the *Little Passion*, 1509–11
 Albrecht Dürer, 1471–1528
 Woodcut, 12.6 x 9.7 cm.
 British Museum, London, UK

PICTURE CREDITS

BBC Worldwide would like to thank the following for providing photographs and permission to reproduce copyright material. If not mentioned below, photographs were supplied by the museums, galleries and individuals credited in the list above. While every effort has been made to trace and acknowledge copyright holders, we would like to apologize should there have been any errors or omissions.

AKG London: 38, 58; Alinari: 84, 105; Artothek: 204, 224; Bridgeman: 78; © Teo Chambri: 151; e.t.archive 100, 135, 178 (*bottom*); © Pedro Feria: 120; L'Ufficio Turistico, Greccio: 50; Giraudon: 200, 212–13; Institut Amatller d'Art Hispànic: 147, 148, 205, 210; National Trust Picture Library: 220–1; © Nicolò Orsi Battaglini: 155; © John Parker: 112, 216; Réunion des Musées Nationaux, Paris: 47, 109; SCALA: 26, 27, 30, 31, 34, 35, 39, 43, 69, 71, 74, 75, 82, 95, 124, 143, 167, 170–1, 182, 187, 196, 201.

INDEX